Dream
Wedding
PHOTOGRAPHY

Dream Wedding
PHOTOGRAPHY

Lorna Yabsley

David and Charles

The book is for my beautiful daughter Gracie, for all the days I missed with her whilst I was out working.

A DAVID & CHARLES BOOK
Copyright © David & Charles Limited, 2010

David & Charles is an F+W Media, Inc. company
4700 East Galbraith Road
Cincinnati, OH 45236

First published in the UK in 2010

A catalogue record for this book is available from the British Library.

ISBN-13: 978-0-7153-3616-8 hardback
ISBN-10: 0-7153-3616-9 hardback

ISBN-13: 978-0-7153-3617-5 paperback
ISBN-10: 0-7153-3617-7 paperback

Printed in China by RR Donnelley
for David & Charles
Brunel House, Newton Abbot, Devon

Publisher: Stephen Bateman
Commissioning Editor: Neil Baber
Editor: Sarah Callard
Project Editor: Cathy Joseph
Design manager: Sarah Clark
Production Controller: Bev Richardson

David & Charles publish high quality books on a wide range of subjects.
For more great book ideas visit: www.rubooks.co.uk

Contents

Introduction

I am lucky enough to have worked in the photographic industry for some 25 years and over the last 17 of those I have established a successful wedding photography business with a solid reputation. I have seen radical changes during that time, not only with the advent of the digital camera but also in the way that market trends and the boom years have grown 'the wedding' into a major industry in its own right.

When I first started out, in the days of film, the wedding market was very traditional. Photographers covered the set shots, generally cramming them all into an intensive, rather over-bearing, hour-long session, keeping everything very staged and formal.

Life for photographers was simpler then. The film (a fairly forgiving medium in terms of exposure latitude) would be posted off and the prints would be returned a week later. The best would be shown to the client for them to choose a set number of images that would be pasted into a finished album. Neither the photography nor the finished presentation was very inspiring, with little choice of albums and frames to offer clients. The whole image of wedding photography was considered rather dated and staid.

Times have changed, thankfully, and today there is a whole new generation of photographers working in a much more creative style, offering a great range of cleverly designed wedding albums and finished art works. Of course, we now have digital, too. People often remark how much easier it must be with digital. I have certainly found the freedom to take an endless number of shots and review them instantly has been incredibly liberating, and my knowledge and understanding accelerated one-hundred fold. But the down side is that we now have to do the job of the lab in the post-production and that is a whole new skill base that photographers must understand and equip themselves with.

Fortunately technology has progressed and the new generation of digital cameras and software has simplified our job. Doubts over quality are much less of an issue than in the early days of digital and the whole workflow process of post-production has improved greatly.

At my studio I have a glass display case containing a couple of old Bronica medium-format cameras. These former workhorses of many portrait and wedding photographers serve as a point of interest for my customers. I recently added to the display a first generation 1GB micro-drive – at the time a huge investment in what seemed like a massive amount of data storage. Even though it is only six years old, in technical terms it is now obsolete and antique. How things have changed and so rapidly!

In this book we will be looking at the different types of wedding ceremonies and receptions, what happens throughout the day of a typical wedding and who the key people are. A full understanding of this is a crucial step towards successful wedding photography. We have all attended weddings as a guest but being there in the capacity of official photographer will require a very different perspective.

We will also look at the 'business' of being a wedding photographer: how to market yourself, meeting a potential couple and securing a commission. Following on is the process of preparing for the big day, including writing the all-important plan, your blueprint for shooting successfully on the day.

In 'The Big Day' section of the book there are many examples of my best work with a commentary on how they were achieved, ordered in the sequence of a typical wedding day. This will help give you some insight and, hopefully, inspiration on what shots can be attempted and how much there is to cover within a very small time frame under often challenging conditions.

In the final sections we will be looking at the post-production procedures, presenting to the client, producing the finished album and an in-depth look at shooting techniques, equipment and software. There is also advice on how to maximize your sales by offering additional shoots to the couple before and after their wedding day.

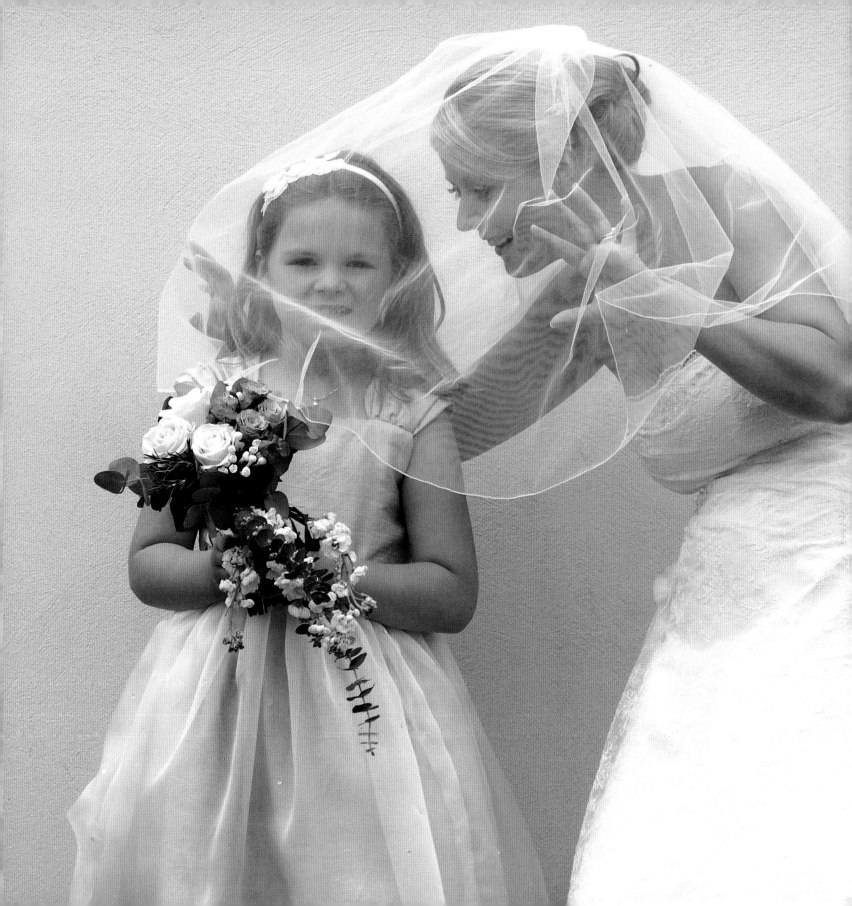

1. Understanding Weddings

Starting out

I had been running a photographic library and shooting studio portraits for some time when I was asked casually to cover a friend of a friend's wedding. Knowing nothing about wedding photography and through more luck than judgement, I duly turned up at the wedding without any preconceived ideas and covered it from my own perspective. At this point in my development as a photographer, that was with a portraiture and editorial eye, far removed from the rather traditional approach of your average wedding photographer at the time.

I was there early so I captured the bride getting ready; I stayed late and covered the speeches. This technique is now familiar with all and is referred to as the reportage approach. I stumbled into it by accident but I soon recognized that there was a demand for this relaxed style and went on to promote myself as a wedding photographer.

Rising to the challenge

In the intervening years I have developed a working practice in line with the ever-changing market and technical advances. A lot of the early digital issues that concerned us have been resolved and now the biggest challenge facing a professional photographer is the competition from the growing number of people who have discovered a passion for photography through the digital medium. I can't say that my method is the only way, only that it is my way.

When I first went into this market seriously, I wanted to offer my clients a fresher approach than the staid and tired old style and at the same time deliver an unobtrusive, discreet service, and exceptional creative images. Even now, with a far more astute and savvy customer base, nine times out of ten the biggest concern for the couple is that the photography should not dominate proceedings and should be informal. This is a big demand and seemingly a contradiction in terms. How can you be unobtrusive and quick but still achieve the shots that most modern couples now aspire to? I have based my entire reputation on fulfilling that role.

My advice to the budding photographer entering into the world of weddings is that first and foremost you need an instinctive natural eye for composition, which will develop and mature over time. A basic knowledge of photography and post-production techniques is vital. You must understand your camera settings and be the one in control of exposures and composition. It is not enough to turn the dial to auto and snap away in the hope that you will capture it all.

Having said that, you don't have to be a technical master. I can drive a car but I have no idea about how the internal combustion engine works. Neither is it about having a huge range of equipment. A very well-known photographer, once said to me, 'If you can't take a successful image with a standard 50mm lens, give up.' Harsh, but the point is that a lot of people's interest in photography is about the shiny and beautifully engineered cameras and gadgets. Personally, I find that bit the least interesting. It has to be about the images you create at the point of pressing the shutter, not the gear in the first instance nor the software tools in post-production. Understanding what you are trying to achieve at that point is what really good photography is all about.

No matter what your motivation, realistically you need to have at least some level of competence before tackling anything as challenging as a wedding. It's a huge responsibility; know your limits and only ever offer what you feel confident you can deliver.

Couples today expect fresh, creative images from a photographer who will be as unobtrusive as possible during their wedding. It's a difficult balance to achieve and certainly not simply a matter of having the latest equipment. Before you even think about taking on a wedding commission, make sure you are confident in your technical skills.

Essential skills

*D*o you have the eye? To be a really good photographer you must clearly have a natural disposition for composition but it is definitely a skill that can be nurtured and worked on. I believe most of us do have an eye; it's not some God-given gift reserved for an elite few. Maybe we just don't recognize it or haven't had the opportunity to tune into it yet.

To make a pleasing, clean composition that evokes an emotional response from the viewer, you must consider not just the main subject but also all the other elements within the frame and how they relate to one another. It is so important to be proactive, looking all the time with eyes in the back of your head for candid moments, learning to anticipate what might be coming next so you're ready for the shot.

There are many different areas of specialization for a photographer: portrait and social, commercial, architectural, landscape, still life, fashion, photojournalism and so on. To be a wedding photographer you will need to draw on all those skills to some extent, which is why I believe it is such a demanding but rewarding job. When finding inspiration for your own work, it helps to look at images by all the different people whose work you admire – not just those photographing weddings.

Technical skills

If you can shoot a wedding from start to finish you will have had to employ all your technical and creative expertise. Over the course of a single day, you will have every sort of shooting situation thrown at you, from still life set-ups of bouquets and pretty detail shots of the bride's gown and finery to shooting formal portraits and key, fleeting moments, sometimes in challenging and uncontrollable lighting conditions.

You need to learn how to adapt when there is no natural light at all, for example during late afternoon at a winter wedding, or when the weather and the light go against you. Bright, midday glare can be just as problematic as wind and rain.

Dealing with people

Confident people skills cannot be overestimated. You will need them in abundance when it comes to handling the friends and family. Charm and humour go a long way when trying to coerce unwilling groups of people into position for a strong, well structured shot. Pre-planning is the key to avoid becoming a loud, domineering and very stressed wedding photographer that is everyone's nightmare. Being a good communicator is just as important as having a good eye, technical competence and business acumen.

It's a huge challenge but by being realistic in what you attempt, there is no reason why you can't achieve some great results and build on your skills.

There is a lot more to wedding photography than taking some pleasant portraits of people looking their best. You will need to be able to develop a very good rapport with the bride and groom in order to capture intimate moments, but be equally capable of maintaining control over a large group of complete strangers.

The nature of weddings

'Everyone loves a wedding. The most important day in a woman's life. The fairytale.' These are all common sayings about weddings, a ritual celebrated universally across all faiths and cultures.

At its heart, a wedding is about two people who love each other, coming together for a lifetime commitment. It is a ceremony and a joyful occasion, bringing family and friends together. We all know this and most of us have attended weddings as a guest. Being a close member of the wedding party brings with it a sense of responsibility to help ensure all goes well but also participation in all the fun and celebration of the day. However, being there in a professional capacity is a whole different matter. Sure, you should have fun with your work but make no mistake it is work, hard work, with huge responsibility attached and consequences not worth considering if things go wrong. I would never undertake the job of covering someone's wedding lightly.

Recording the day

As the photographer, you will be up close and personal not only with the bride and groom but also with their relations. I often feel very privileged to be allowed this window into family life. As a wedding photographer, there are many things that you should keep in the back of your mind in case you get carried away and turn the whole event into a fashion shoot. Remember that first and foremost it's a wedding and the couple and family's enjoyment of their day is paramount. Yes, you must deliver the best shots possible, but not at the expense of dominating the proceedings and becoming a complete pain in the neck. This will do nothing for your reputation or your blood pressure.

Sometimes it is difficult to satisfy the couple (who will no doubt have a more up-to-date vision of how they want the shots to look) as well as the parents and older family members. A good plan, resulting from your consultation with the couple, will have any compromises that need to be made in place.

To record the day completely you will need to know as much, if not more, about the day than the

bride herself. This will allow you to deliver a cohesive collection of images that capture all the key moments, from the bride getting dressed to the first dance and all that takes place in between. It's only one day with many different rituals throughout and there is a very short window of opportunity for the photographer to come in, get the shots and move on. However, it helps clarify things to understand that most weddings consist of three main events – the ceremony, the reception and the party.

After the wedding

From shooting on the day to delivering the final images is a long journey. In reality, taking the pictures is only the tip of the iceberg; now the real work begins.

The first stage is to download and back up all the images and the mantra here is, 'back up, back up and back up.' By this, of course, I mean make copies of all your files, before re-formatting your cards or, if you are shooting film, then deliver it by hand to your lab or use secure carriage for both delivery and return.

Then it's the edit. Hopefully you will take a measured approach when shooting, rather than just firing off thousands of frames in the hope you will capture something. This should make the job manageable. Your client will want to be presented with a comprehensive collection of images that cover all aspects and reflect the day, with a certain amount of choice for each sequence of shots. Don't inundate them with too much; only include the best and dismiss any that are not really strong or relevant.

Finally, once the clients have made their selections, there are the final prints and albums to produce. Once they have taken possession of the finished collection, the photographer's work is done but this could be up to a year after your initial consultation with the couple. A wedding commission is a long-term project, and there is a lot more work involved than people realize.

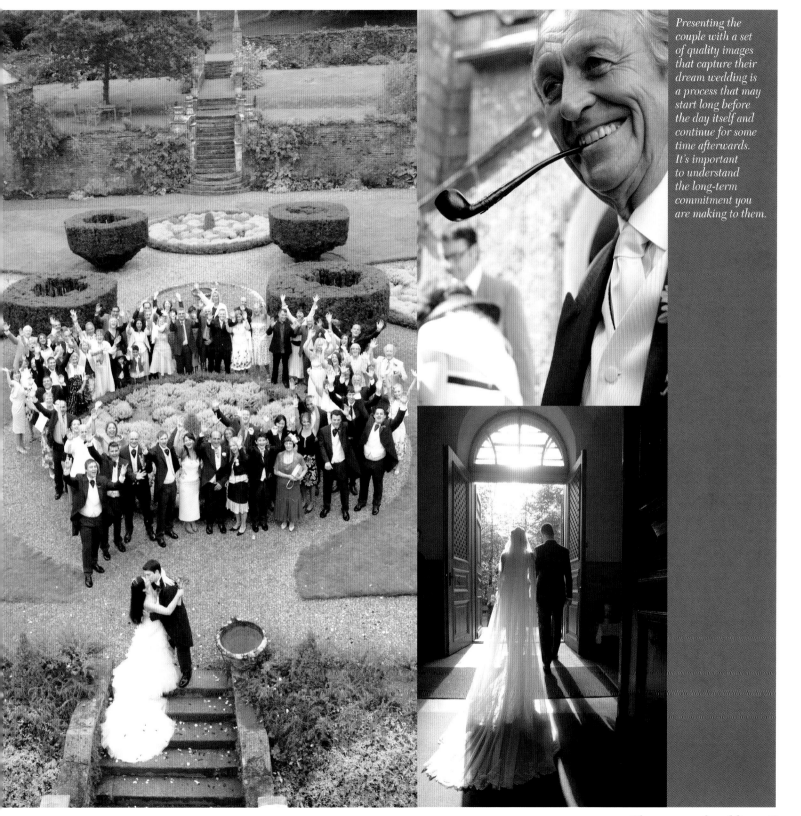

Presenting the couple with a set of quality images that capture their dream wedding is a process that may start long before the day itself and continue for some time afterwards. It's important to understand the long-term commitment you are making to them.

Different types of wedding

*A*lthough most weddings follow the same basic structure of a ceremony followed by a reception, there are many variations within it that you have to prepare and adapt for.

Weddings are celebrated universally across all different cultures and faiths, each with their own traditions. Christianity, Hinduism, Judaism, Islam, Sikhism and Buddhism are just a few of the 'main' faiths. Then consider that within the Christian faith, for example, there are again all the different denominations, such as Baptists and Catholics, which may have variations in the marriage ceremony. Sometimes a bride or groom will be marrying a person from another faith or culture and may choose to observe certain aspects and pay homage to the other's faith within the ceremony.

As the photographer, it is vital that you have a full understanding of the significance of the various rituals and the sequence of events that will be taking place over the course of the wedding. A good plan will have all these important considerations in place. A very traditional Hindu wedding will probably employ a specialist wedding photographer, although a lot of younger couples now want a less formal approach and may look to a more contemporary photographer. Regardless of your style, the important traditions of the ceremony must be recorded.

I once covered a wedding in Poland with a Polish bride and a Russian groom and the wedding was a mixture of unique rituals and customs. I knew very little about either culture and was out of my comfort zone but I made sure I discussed at length with the couple what I should expect on the day, when it was appropriate for me to take shots and when I should retreat. It was a fascinating window but you need to approach any new situation like this with all the facts.

Styles and sizes

Within the various faiths and cultures, there are many different types of weddings: small informal gatherings or large formal events, civil ceremonies, same sex civil partnerships, private functions at the family home or a hotel venue. They may take place in summer or winter, in the open air or by candlelight. Just like the couple, every wedding has its own style, regardless of culture.

Covering larger events you will inevitably end up with more shots than for a smaller function but the set shots on your plan will cover pretty much the same ground as for a smaller wedding. It isn't necessarily true that the bigger the wedding, the more difficult your job. There is only one bride and one groom, no matter how big the wedding, and families vary in size no matter how small it is. Either way, you will still need to cover the main set images that you agreed with the couple and noted on your plan.

Locations

It is usually much more straightforward to cover a wedding that takes place at a single location. If the couple are staying at the venue and getting ready from there, then better still. It can be more challenging and potentially stressful to be in a number of different locations throughout the day as you have to account for travel time, parking, loading and unloading gear.

This is often the case, however, so you need to make sure you are well prepared in advance. This will entail visiting each venue in turn, generally starting with the groom and the boys at the ceremony venue. You might then need to travel to the bride getting ready at home, and then have to dash back to the ceremony venue for the marriage and, finally, make your way to the reception.

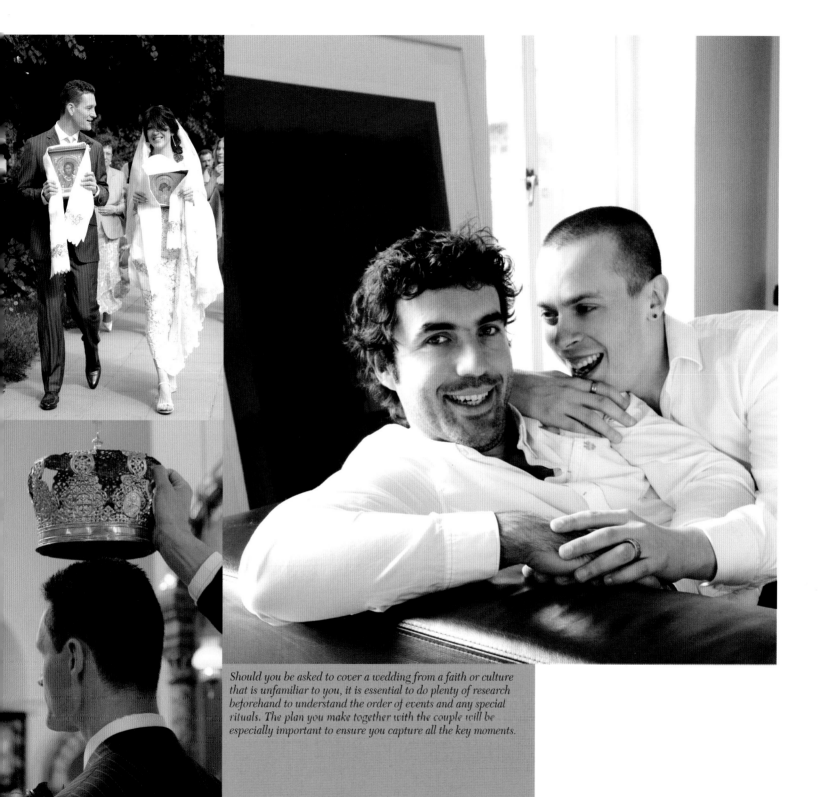

Should you be asked to cover a wedding from a faith or culture that is unfamiliar to you, it is essential to do plenty of research beforehand to understand the order of events and any special rituals. The plan you make together with the couple will be especially important to ensure you capture all the key moments.

Your style and approach

As well as taking into account the type of wedding the couple are staging, you must also consider their personalities to determine the kind of shooting approach you will take with them. They will, of course, want your spin, style and edge to come across in the images – why else would they have chosen you? You must also establish how much they are prepared to collaborate with you to achieve the shots.

I always say that working with a couple is a 50/50 process. You can give them great direction and put them in the best possible light but it is up to them to collaborate with you. It's so much easier to achieve great shots when you are working with people who are not intimidated by the camera but invariably most people will tell you, 'I hate having my picture taken,' so it can be a challenge and it needs to be addressed.

Couples and family dynamics vary hugely and what you can achieve with one couple's wedding may not be possible with a different couple, even though all the other factors in the wedding may be very similar. On the one hand you may have a very gregarious and outgoing couple who are totally up for the photography and who will love the attention; on the other you may have a very shy and formal couple who will struggle to play up to the camera. Different approaches will be required.

Similarly, some families are very close and openly affectionate with each other so close groupings, with everyone leaning in to each other, work well. It is a delight to photograph people like this. However, other groups are much more formal or distant and will feel very awkward at physical contact. You need to pick up on this quickly by observing their natural body language on the day and arrange poses that will help them feel and look comfortable.

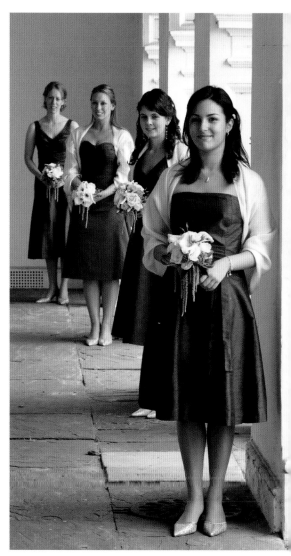

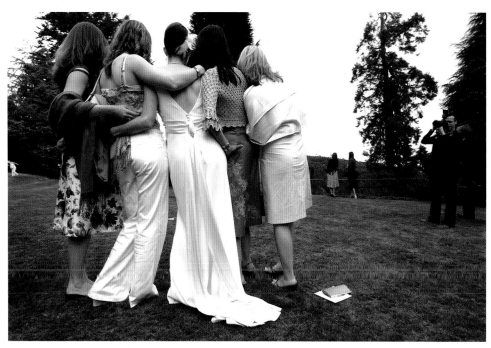

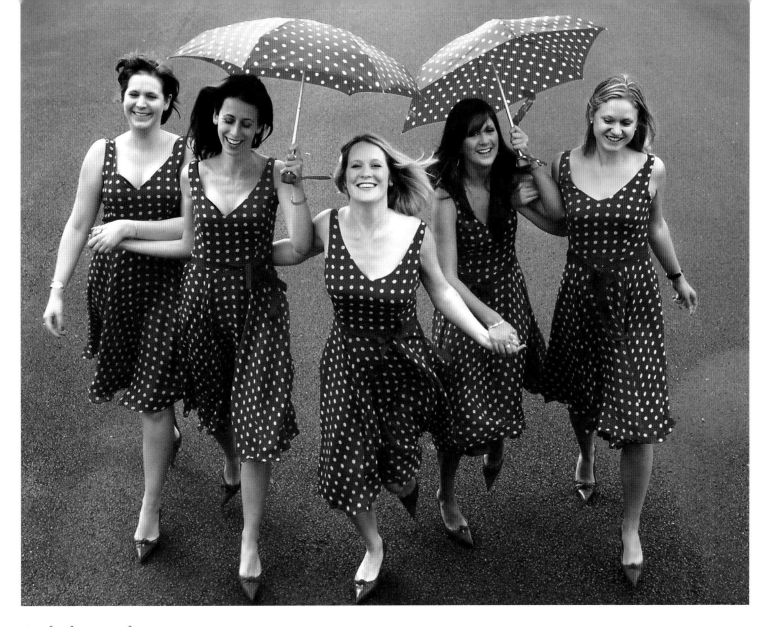

Grab shots and stage-managing

Many couples look at my albums and tell me they want to use me because my shots look so natural and unposed. I am always pleased as this is what I am hoping to achieve in my work, however, I have to explain to them that while there are always a number of shots that are literally captured moments — the lucky grab shots when you caught a spontaneous laugh, a kiss or an emotional tear — in reality, stage-management is often involved. I manage to do so, though, in such a way that the people involved don't feel like they are being 'posed'. Much of this method relies on pre-planning the composition before putting the people into position. You look at your location and find what will frame your subjects or give you a nice, clean, neutral background to work on.

Couples will often ask me to 'just take lots of lovely, natural pictures' and expect the shots to fall into place magically, not realizing the process involved in achieving a great image. Another regular occurrence is when an impromptu group gather together then grab you and say, 'Can we just have a quick shot?' Suddenly you are faced with eight or ten people all huddled together, some taller people completely obliterating the smaller ones, half of them in the shade, half out. Obviously, you will have to manoeuvre them a bit to improve the composition.

If you try to approach all your shots in this rather informal way, you are not going to achieve the clean lines and strong graphic images the couple will expect. Grab shots do, though, have a very important place and you should always be on guard, anticipating the moment and ready to shoot. Equally, when you do stage-manage a shot, the trick and skill is getting it to look natural and effortless and arranging it quickly before your subjects begin to lose interest.

Important people

*Y*ou need to acquaint yourself with the key people of the day. I operate a 'high end' wedding service so I make it my business to introduce myself to the bride's parents, wedding planners and venue managers before the wedding if possible. Certainly, on the actual day, I take time out to introduce myself to the bridal party and the person conducting the ceremony.

It will depend on what level of service you are offering your couple as to how much time you will invest in all of this PR, but a level of personal care to the family and wedding professionals involved will pay dividends. The key people will be far more willing to cooperate and help you, as they will appreciate the trouble you are taking.

You have a very tough job on your hands but always remember it is a big day for the family. They and the professionals will be feeling the pressure, too, so they will be really grateful if you consider the day from their perspective as well as your own.

You will obviously have met the couple well beforehand, although there may be the odd occasion when, for whatever reason, you may not come face-to-face with the groom until the actual day. If this is the case, try to speak on the telephone to bring him on side before the wedding.

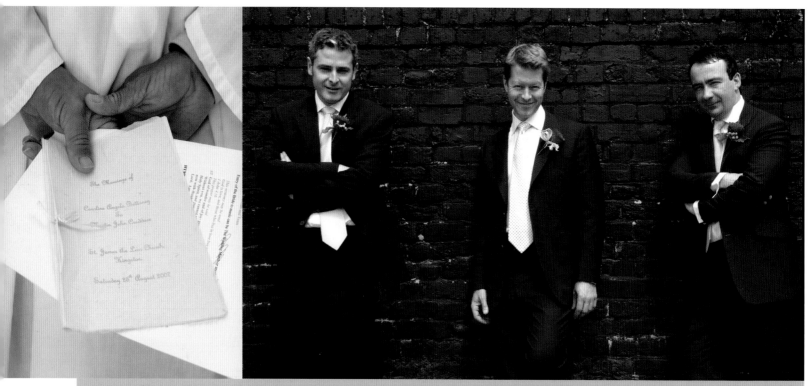

It may seem like an additional bother, but introducing yourself to the most important people at the wedding will make your job easier in the long-run. Identify helpers among family, ushers or bridesmaids who can assist with the group photo, be polite and reassuring to the parents and instigate a spirit of cooperation with the officials at the service and staff at the reception venue.

The parents

The family are, of course, key. Make sure that you are fully aware of any family politics and any potential problems. A good plan will have all this in place. If you haven't met the bride's parents, make sure you introduce yourself on the day and briefly run through with them what you are going to do in case they decide to give you a last minute list of shots. Reassure them as they will be quite stressed and will want everything to run very smoothly.

You probably won't see the groom's parents until you arrive at the ceremony. Make sure you identify them as soon as possible because it can be difficult to discern the important family members from the guests. As well as the shots on your plan you want to get as many informal portraits as possible of the key people.

Ushers and bridesmaids

The best man, ushers and bridesmaids are all people that you need to have on your side. In their official capacity at the wedding, it is their job to help the proceedings run smoothly, although they sometimes forget, distracted by the celebrations. Often it falls to the poor old wedding photographer to remind the wedding party to leave the church in order to get to the reception venue on time. So make a point of introducing yourself and discussing your plans, explaining what is required of them if they are involved. Your plan will have highlighted particular people in these groups – use them to your advantage.

Officials and staff

The wedding official, whether it's a priest, rabbi or registrar, will need to be made aware of your presence and role at the wedding. There will inevitably be restrictions and rules on what you can and can't shoot, when and where. Good manners and a touch of charm will help you win their support.

Similarly, invest a little time with the venue events managers and catering staff, making sure that your plans are going to tie in with theirs so that everyone can work together without hiccups in the timing and schedules.

At some weddings there will be a master of ceremonies attending. He can greatly assist you when it comes to gathering specific people and guests for the groups. Make sure he is working from your plan, not the other way round, and is clear about how you want to achieve the shots.

Mostly it is common sense: identify the key people, and introduce yourself. Make sure your plan is available for them and that they are aware of what you are trying to achieve. In turn, be aware of what their plans are. Are there are any areas of conflict? If so, they can be ironed out before any problems arise. A simple, 'Hello, my name is Lorna and I am taking care of the photography today,' is all it takes.

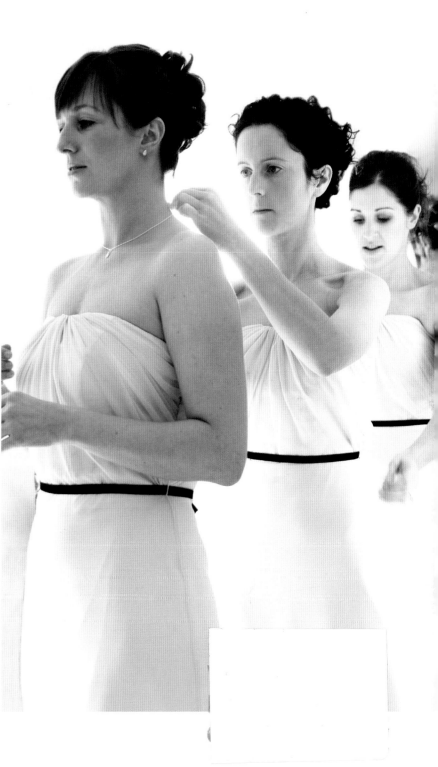

2. Securing the Commission

Getting established

*P*ursuing weddings as a semi-professional, taking on a few paying commissions in your spare time, can cover the cost of an expensive hobby or it may even help supplement your income. However, as a paying job you are entering more serious territory than delighting friends and family with gifts of your photos and you will need to take a measured look at what you are offering for the money you are asking. There is a cost involved in getting it right as well as a moral obligation to deliver.

If you want to pursue photography professionally as a full-time career, either specializing in weddings or including them in a wider range of services, then you will need to learn business skills as well as photographic ones. Like most things in life, it looks easy from the outside until you try, but on a positive note, unlike a lot of start-up businesses, you can set yourself up on a small scale for relatively little outlay. With hard work, skill and determination you can establish yourself in your own business.

Taking pictures will take up maybe 25 per cent of your time if you're lucky. The rest will be spent making sure the work is coming in and on image processing and post-production. There are many different ways to build your business model. You could outsource a lot of work or bring everything in-house and do every stage yourself. All of the options will need to be explored before you hand in your notice at work.

Researching the market

Having established that you enjoy it and are technically competent, you must first do your market research. Who are the other photographers in your area? There will be lots – photography is one of the world's most popular hobbies, and becoming increasingly popular as digital cameras improve.

Who's work do you like, why do you like it, how are they presenting themselves, what are they charging and what information are they giving out? Find out if they have fixed packages and prices, what products and print types they are offering and whether they appeal to the budget, mid-range or high-end market. Look at who the most respected photographers are, why that is the case and the venues they are established with. Don't confine your research to your own region, look at the key players on a national level

Moving from amateur photographer to professional, you will be required to raise your game and provide a high level of professionalism and competence

Offer a free pre-wedding shoot to your couple when they book as an incentive to secure the commission: it will also be a good opportunity to practise and build a good working rapport.

as these are the photographers to aspire to. Gathering all this information should not intimidate you; everyone had to do their first wedding. It should give you some great ideas to bring into your own profile as a photographer and, hopefully, pinpoint what you are going to offer and to which market.

Finding your niche

Having done your market research, you will have a much stronger idea about the direction you want to take. You must now try to develop a package and price for your service. This is difficult: markets change, recession bites, competition increases. I am now competing in a market that lots of people want to join and there are many photographers offering unbelievably great deals to the customer. To break into the market, before you have too many overheads and staff to pay, you sometimes have to be prepared to give a lot for little return.

Finding what's right for you and your pitch will take careful analysis. My advice is to keep it simple. You will discover, having done your market research, how confusing some photographers make their packages and pricing. It must be very difficult for the customer, who usually has no prior knowledge of the wedding photography business, to work out what will be best for them.

My strategy is to offer a 'starting from' price for the photography on the day. This covers the key aspects of the wedding and I will charge more for a bigger and more complex function if I need to. I charge for albums and prints but make sure I have a simple, affordable album to offer to keep the initial quotes reasonable. You should look to maximize your sales post-shoot as this is where you turn a profit.

Always be transparent and up-front about your charges. The industry has developed a bad reputation with unscrupulous practitioners hiking prices and hiding the true cost of the finished package. There is no crime in maximizing sales, but always be clear about what the likely spend will be overall. Bear in mind that customers booking you for the day won't know at that stage how many shots they are going to want in their

finished album or how big they are going to want their finished framed print.

Consider your costs

Your one-off set-up costs will be your capital input. On the most basic level this will be your bag of kit, including a back-up second camera body and lenses, a reasonable computer with a good processor and plenty of memory, some photo-editing software and a portfolio. Basic running costs include a business card, stationery, a little brochure perhaps, a web presence, professional indemnity and equipment insurance as well as car and travel expenses. If you are offering prints and albums these costs will also need to be factored in.

When establishing your rates you can only charge what the market will stand given your position in it, unless you have something unique to offer, commonly referred to in the business world as USP (unique selling point). This could be something as simple as sourcing an unusual or hand-made frame to include in the package, or it could be a free pre-wedding shoot with the couple, with free framed prints for them to give to the mothers on the day. Whatever you decide, you will need to set yourself apart from the competition to ensure a couple choose you over them.

From the outside, it seems like a great career idea to do what you love and make money at it as well. And when you look at what some photographers charge it can seem like an unbelievably lucrative job. But consider this: for an average wedding you may only be shooting for six to eight hours, but with the consultations, calls and reconnaissance taking up to four hours and post-production, viewings and finished collections a further 16–18 hours, you start to see the real time involved. Add the expensive outlay, the pressure of the responsibility and the strong competition you face and it may not seem like such a dream job after all.

I don't say this to put you off, wedding photography can be a fantastically rewarding and creative career, but don't be under any false illusions about what is involved.

Promoting yourself

By employing people with the right skills and with a few good shots, you can produce a sexy looking brochure, cool advertising, and a slick and cleverly designed website. Most photographers can come up with enough 'money shots' for that. But savvy customers will want to scratch beneath the surface and see a wide and varied selection of images to feel confident enough to book you.

When you first start out in business it will be difficult to assemble enough material for a substantial body of work to show to prospective clients. My advice is don't pretend that you have covered hundreds of weddings when you haven't. Be honest, start small and build up your portfolio and rates gradually.

Why not arrange a shoot and mock up a few images? Not only will it be good to practice but also it should give you a few great shots for your portfolio. No doubt you will have some other favourite shots, portraits or landscapes, which you could show if your wedding selection is a little thin on the ground.

Two rules apply to your portfolio. Firstly, make sure that your prints are really good quality and that you have mounted them correctly and perfectly. As you gain experience and start to offer more, it's a good idea to display your portfolio in the actual albums you will be offering the clients.

Secondly, be honest about what you are showing; if it's a mock-up shot, then say so. If you're frank about the fact that you are just starting out, the couple should understand and presumably this will be reflected in your rates.

Your portfolio is obviously an essential sales tool but you will also need to look at other ways of marketing your services and have a budget in mind. It can be very expensive so, unless you have a very large start-up fund, you will need to be very careful where you invest your money.

Websites and bridal fairs

Websites are expensive to construct and maintain but despite this I would say you definitely need to have a web presence to compete in today's market. Even if it's just a few well laid out pages with a small selection of images and words along with your contact details and a tariff.

Exhibiting at bridal fairs is another way to put yourself directly in front of potential clients. Go and attend a few as if you were a customer and see what local competition you are up against. Often wedding venues will hold small, informal fairs and this can be a good way to start before tackling the bigger national professional shows. Any links you can build with a wedding venue should be nurtured. If you can get on to their list of recommended photographers and ask them to hand out your brochure to prospective clients, it will really help.

Over the years I have developed a great symbiotic working relationship with some of my regular venues. They know exactly what to expect from me and I know how they like their weddings to be handled – a win-win situation.

Advertising and editorial

Display advertising in the wedding press is expensive so it pays to try to offer something to your regional press, such as a few really good shots for them to use in their editorials. You could pay for a very small advertisement initially on the condition that one of your shots is used in the magazine or paper with your credit beside it.

If you are starting out, then send out a press release highlighting your services. Also, if you are covering a wedding that has an unusual theme or story angle to it, send it in with a few words – anything that you think will look good on the pages and that the magazine may print. Nurture contacts within the editorial and advertising department but don't pester or you will alienate them.

The best and most effective advertising you will get is through word of mouth, which is, of course, entirely free. If you do a good job and impress your clients, this will come in time.

Click,
Click,
Click...

Meeting the couple

You have established your rates and the service you are offering and have put together your portfolio. By now, hopefully, your marketing strategy is working. The phone will ring or you will receive an email with your first enquiry.

Having successfully attracted interest in your services, you have lured the fish to the bait. You now need the bite and to land your catch. Often the first point of contact is an initial telephone enquiry. Remember, first impressions are very important. You can make or break your chances of securing a commission on this first contact, so be prepared.

Generally it is the bride who you will be talking to but it could be her mother or the groom. They will, of course, be gathering information from other photographers as well and there will be a lot of questions that you will need to be able to answer confidently. However, try to avoid getting into a lengthy question and answer situation, or an hour-long rambling sales pitch. Instead, establish a protocol for handling sales enquires. Your objective at this stage is to secure an appointment to meet the couple which I like to offer as a 'consultation'.

First and foremost, take down all the relevant details on the phone. I use a printed enquiry sheet to help prompt me. In the course of taking down all the details, you can engage in some friendly chat, build a rapport and gauge what type of wedding the couple are planning and what they are looking for.

The first thing to find out is whether you are available on the date of the wedding. It seems obvious, but taking control of the conversation shows that you are organized and professional. Take the names of both the bride and groom and ask roughly how many guests will be attending.

Don't forget to ask how they heard about you; this will help you find out how your marketing strategy is working. Always take phone numbers and email addresses to follow up: you may not be able to secure an appointment initially, but by sending out your literature, an email and then a follow-up call, you may be able to arrange an appointment and ultimately secure the commission.

Remember to give them a chance to talk about their plans for the day. Take notes on the enquiry sheet (these will be invaluable at the consultation) and listen to their wants and concerns. Explain how you like to work and guide them briefly through each stage, from the initial consultation to shooting on the day, through to viewing and selecting the final images. You will also need to give them some guide prices at this stage.

Reassure them that every wedding has its own set of requirements and that you can establish all the details during the consultation, which is the first stage for planning the photography. Explain that you will need one hour for this to show them examples of your work, draw up a preliminary plan and discuss rates.

At the end of the telephone conversation you should have a lot of information on your sheet and hopefully will have made arrangements to meet for the initial consultation.

Where to meet?

The consultation could take place at your premises, their home or the wedding venue. There are pros and cons with all these options but wherever you decide, always make sure that you look presentable, you are on time, your portfolio is pristine and you have literature and price guides for them to take away. If they like your work, that's great but you also need to convince them that you are the right person to be present at their wedding on the day.

You may be lucky enough to have a dedicated office area or studio. If you are bringing the client into your space then make sure it reflects you and how you want to be perceived by your potential client. If you don't have a dedicated workroom, then use the best room in the house. Make sure that it is clean, tidy and clutter free. Always make sure that you can give 100 per cent concentration to your client. Turn off the phones and if you have children, make sure they are being looked after elsewhere. If they are bringing their children with them, have some toys handy to occupy them.

Meeting in their own home, the couple will be relaxed but may be too relaxed and easily distracted, so make it clear that you will need an hour of their

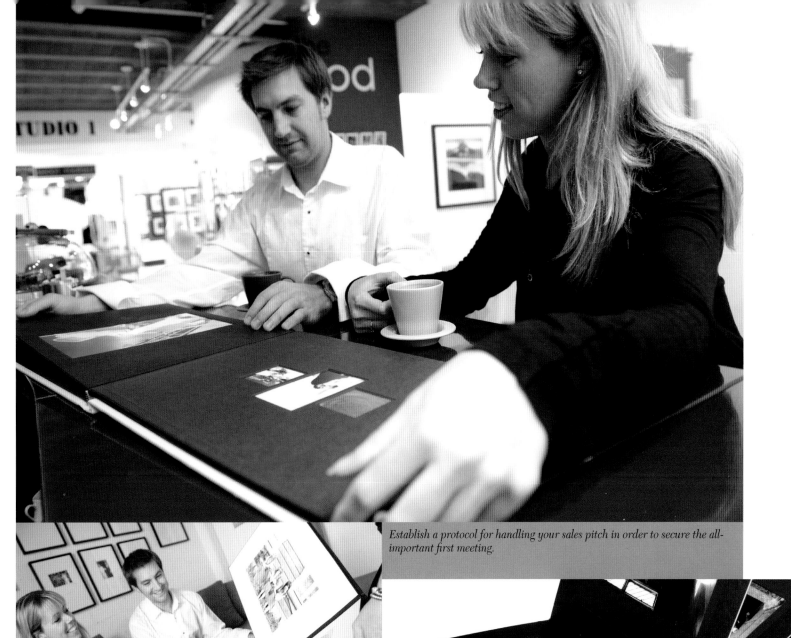

Establish a protocol for handling your sales pitch in order to secure the all-important first meeting.

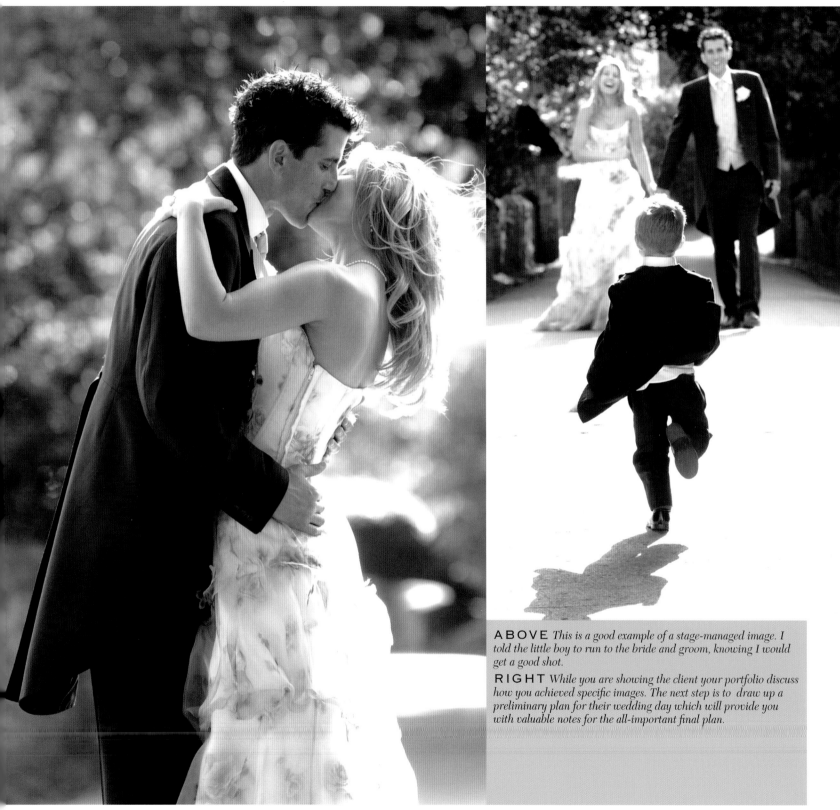

ABOVE *This is a good example of a stage-managed image. I told the little boy to run to the bride and groom, knowing I would get a good shot.*

RIGHT *While you are showing the client your portfolio discuss how you achieved specific images. The next step is to draw up a preliminary plan for their wedding day which will provide you with valuable notes for the all-important final plan.*

time and a space with good light where you can show them your portfolio.

If you agree to meet at the wedding venue, make contact with the establishment to let them know that you will be meeting the couple there and that you will need a quiet corner to sit and discuss arrangements. This should be perfectly acceptable as the couple are their customers. Use this opportunity to network and develop bonds with the hotel/events manager.

The consultation

It is worth having a structure for the consultation as you will have a lot of ground to cover in one hour:

- Meet and greet
- Coffee/tea and exchange general small talk
- Show your portfolio
- Draw up the preliminary plan, listing times, people and places
- Explain your service, what is included and discuss your fees
- Close

First impressions are very important so shake hands confidently and explain what you will be covering over the next hour. From the outset you should gently establish that you are leading the consultation. They will welcome your guidance. Bear in mind that at this early point in the wedding planning they probably don't know where to start.

Begin by showing them your portfolio. This eases them into the right mindset and will get them excited, anticipating their day. My portfolios are made up of the very best images from many different weddings, run in the sequence of a typical wedding day. I find this helps when I start the process of writing the preliminary plan as I can refer back to the portfolio to illustrate points I need to make in order of the day's events.

Ideally, you should also be prepared to show an entire wedding, or at least an edited version, in proof form. This can be daunting as obviously not every shot that you capture at a wedding is going to be a 'money shot' so you will have to use your judgement about what to include in the portfolio.

While they are looking through the images, talk about how you achieved them. This will give them

some insight into the process of actually being photographed on the day and should take around 15 minutes. Then move on and offer to draw up a preliminary plan for them. This should take half an hour at least and it's important that you don't rush it as you will need to discuss in detail every aspect of the day. Ultimately, should the couple decide to book with you, the notes you make during this time will form the all-important final plan.

The preliminary plan

During the initial consultation with the couple you may not be able to pin them down to all the specifics. This may well be the first time they will have thought about the wedding in such a time-structured way. It can be a daunting prospect so offer lots of reassurance and guidance. Remember, your objective is to secure a booking. Don't push them too hard as more detail can be added later and a second consultation may be required.

When writing the preliminary plan, the first thing I establish is the time of the ceremony, even if it is likely to be changed. That way you can work backwards and forwards from this point, taking all the other timings and events into consideration. The couple may be very organized and already have worked out a schedule but you will still need to break it down carefully as it certainly won't have been written with the photography in mind.

They may also have unrealistic expectations of what is possible within the time frame. For example, the horse and carriage ride from the church to reception may take half an hour and the hotel has planned to seat everyone just an hour after they arrive at the reception. Despite this, the couple want the full range of photographs including endless lists of extended family for group shots. You will need to be able to find a solution – in this job you are as much a wedding planner as a wedding photographer – but don't promise them anything that will be impossible for you to deliver.

This is a good opportunity to bring up the subject of family politics. Be tactful and sensitive when discussing this. I point out that it is rare to find a family without some sort of issue, which generally makes them feel better about telling you that the groom's parents are estranged and there are children from his first marriage to consider.

Finishing off

Make sure you have prepared a comprehensive breakdown of the service you offer and price guides for prints, image discs and albums. You may have already sent them your literature but by now you should be able to firm up a price and package for them to take away and consider. It is important to end your meeting having established a great rapport as well as a thorough preliminary plan. I generally close the meeting by saying that I understand they need to go away and think it through but I remind them that if they want to secure my services they should do so as soon as possible and for that a deposit will be required. Explain that once a deposit is paid you can put everything in writing and forward them the full plan.

3. Planning the Day

After the commission

*O*nce the couple give you the go-ahead, the first thing to do is to open a client file. Everything must be recorded, and all correspondence kept safe. This file could stay 'live' for a year or more and many changes will be made between the planning stage and the actual day. If you intend to cover other weddings you will need to be very organized about your housekeeping. You cannot afford to turn up on the wrong day or be late. This file is where you will keep the back-up discs of all the images once they have been taken, as well as all the correspondence and accounting details, such as the deposit payment receipt and balance payment receipt.

Next, secure a deposit and send a letter of confirmation, detailing the wedding date and venues. The letter should also include the price agreed, what is included and what your payment terms are.

Write up the plan from the preliminary one you made at the consultation. You may not have all the information and it will no doubt be amended before the wedding but it's a good starting point and will really help the couple refine their plans. As photographers, we are perhaps the only service provider at the wedding who is so closely involved throughout the whole day.

It may be quite some time from securing the booking to seeing the couple again on the day. If there is a lot of time between the wedding and the initial consultation then it is probably worth scheduling another meeting closer to the day. Some couples book up to two years in advance if they are really keen to secure the photographer and venue they want. In those circumstances, you will definitely want to refresh your memory and meet again.

Using an assistant

Once you have a firm idea of what will be required from you on the day, you can decide whether to use an assistant. I generally do use one; in fact I am lucky to have a great team working with me throughout the entire job. I like to build a strong, well-rehearsed working relationship with my assistant – or should I say second photographer. Establishing a good working method and rapport will take a huge amount of pressure off the working day for both of you and give the client even more images to choose from if the wedding is shot from two different perspectives.

I would say the larger the wedding the more a second photographer or able assistant is necessary, not least as a back up should you fall ill or have an accident. If it is a small, more intimate gathering then perhaps a second photographer is overkill and could seem a little intimidating to the couple and guests on the day.

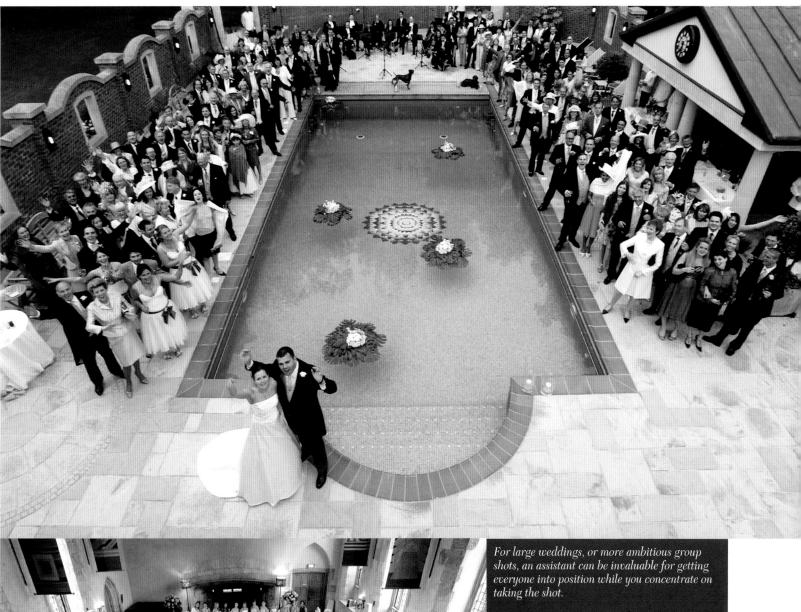

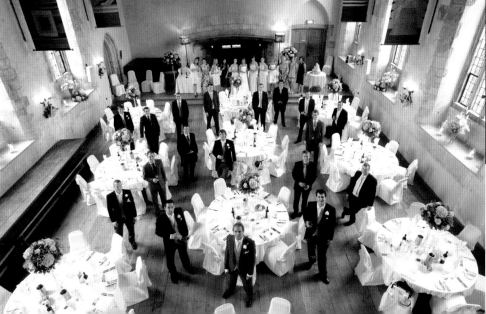

For large weddings, or more ambitious group shots, an assistant can be invaluable for getting everyone into position while you concentrate on taking the shot.

The sequence of events

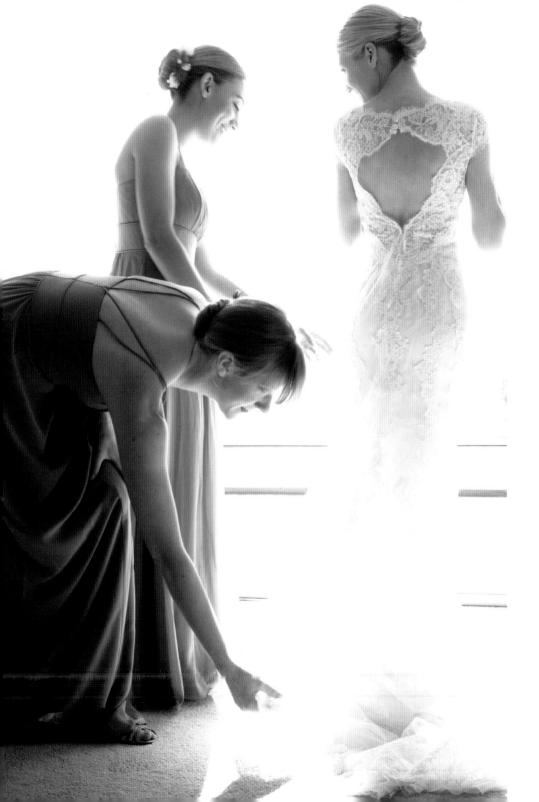

*H*owever much weddings differ, the vast majority follow the same basic structure, at least until the end of the ceremony. Familiarizing yourself with the order of events will help you to plan your time effectively and stay in control on the day.

Many contemporary photographers start their day with the preparations of the bridal party, usually with the groom and 'the boys' (the best man and ushers), as the bride will need more time to prepare and she won't want to be in her dress too long before her entrance at the ceremony.

Often, the first time you'll meet the boys will be at the ceremony venue, unless you decide to arrange something a little less formal. Sometimes, for example, the boys take part in their favourite sports activity and this can be an unusual and fun addition to the finished collection. I have covered a variety of different events including a shooting party and an early morning game of golf. However, usually wherever you choose to meet them, they will be suited and booted and ready for the imminent ceremony.

The bride and girls will be getting ready elsewhere, sometimes at the bride's parents' home or a hotel venue. Wherever it may be, you will always find them in the bedroom amongst an array of bags, shoes, make-up, flowers, tissue paper, champagne and general girly mayhem. It is your job to pick your way through this chaos in order to get your shots, without causing too much disruption while you do so. You then have to head straight to the ceremony venue to prepare for the next stage.

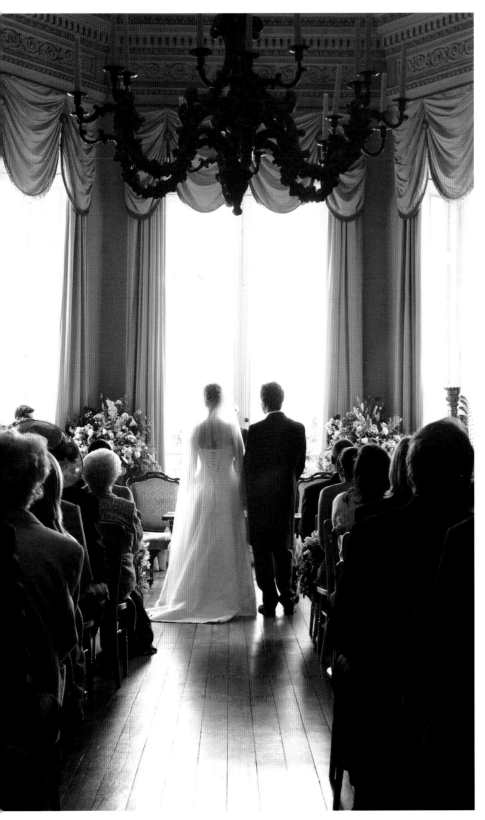

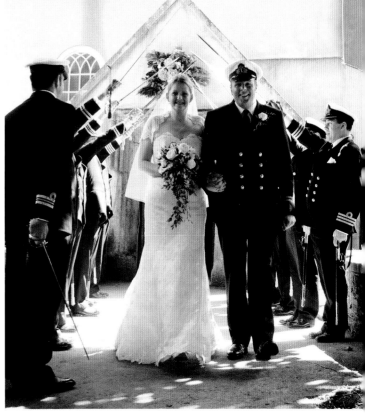

The marriage

About half an hour before the ceremony officially begins is the true starting point of the wedding day. The guests are assembling, the groom and best man are getting into position and the bride is (hopefully) in her dress. Then, again depending on the type of wedding, the marriage commences.

Celebrations

The couple emerge as man and wife and the celebrations begin. Usually, there is still a fair amount of formality at this stage, before the real party starts in the evening. Traditionally, the reception was the party and the couple would leave before the guests. This happens less these days as most couples prefer to stay on, keeping the reception and wedding breakfast in the afternoon for close family and friends with additional guests arriving for the evening party.

The wedding celebrations will vary hugely across different faiths and cultures, so the important peculiarities of these will need to be considered, but no matter how the couple choose to celebrate there will always be food, drinks, speeches and, of course, dancing. How long you stay on at the wedding will depend on the package you have agreed with the couple.

The final plan

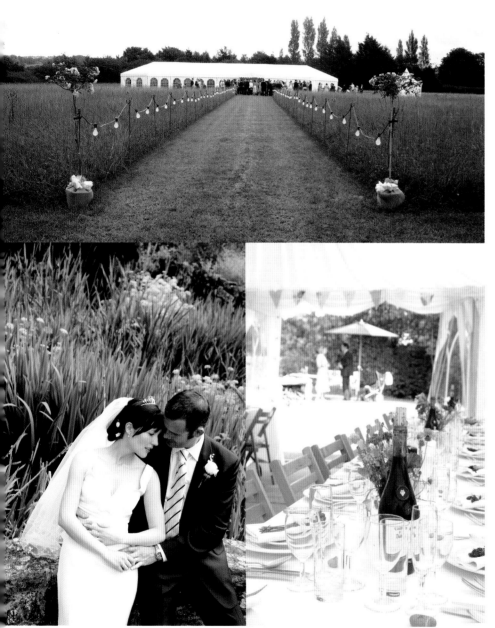

*T*his is the blueprint for the day. Writing up the final plan is the single most important job of any wedding photographer. It is more than a mere schedule of times; it forces you to think through every aspect of the day and foresee any potential pitfalls. Listed are timings: who, what and where. It is a crucial document to ensure that you can keep up and cover all the aspects of the day quickly, quietly and efficiently. It helps keep you focused, calm and running on time, which in turn will free you to be creative with your camera work.

The plan will list all the key people, enabling you to address them by name when you call them for photos, as well as reminders for 'must have' shots. It needs to be finalized with the couple and will serve as a reminder of what you have agreed and what is expected of them. Make sure you have extra copies printed out to give to the wedding party members who have agreed to help you when necessary. I also like to make sure that I have emailed a plan to the venue manager or, if it's a private function, to the catering manager or wedding planner as a matter of courtesy. The more people you have on your side the better.

On your own master copy you can write notes to yourself regarding routes, parking and so on as well as any sensitive issues regarding family politics. You do not want to force the bride's mother and father together in a family grouping if this is the first time they have spoken or seen each other in ten years. Nor do you want to call for the bride's father if he is deceased.

This is an example from a typical traditional wedding day.

The Plan

Saturday 5 June 2010 Ref: Roberts-Davies
- The Wedding of Thomas Roberts and Catherine Davies
- Wedding at Holy Trinity Church
- Reception at The Manor House Hotel

11:15 The boys at the church
NB. Please be on time and don't forget your buttonholes
Tom
Tom and Tom's son James (age 7)
Tom with his best man Colin
Tom, Colin, James and five ushers

11:45 Lorna to leave for Catherine's parents home

12:00 At the bride's home
Detail shots of flowers, shoes, dress, etc.
NB. 12.15 bridesmaids to be dressed and ready, Catherine's hair and make-up to be completed

12:15 Catherine getting dressed
NB. Please keep room clutter free

12:30 Portraiture of Catherine

12:45 Catherine with bridesmaids sister Anne, Jane (niece age 6)
and Sophie (Tom's daughter age 5)
Catherine with her mum

1:00 Lorna to leave for church

1:15 General informal shots of the guests arriving at the church

1:30 The ceremony
Bridesmaids arriving and bride arriving – vintage car
Catherine with her father
General overview of the wedding ceremony
Signing the register
Walking down the aisle

2:10 Outside
Catherine and Tom outside the church
General informal shots of the guests outside, confetti etc.

2:30 Confetti and leaving church

2:45 The Manor House Hotel
Champagne and canapés to be served on the terrace
(weather permitting)
General informal shots of the guests throughout the reception

3:00 Family groups
Catherine and Tom with:
 Catherine's mother Elaine and father Chris
 Tom's children James (age 7) and Sophie (age 5 bridesmaid)
 Sister Anne (bridesmaid) and her husband Paul with
 children Jane (age 6 bridesmaid) and Mark (age 8)
 Brother Carl and partner Stephanie
Catherine and Tom with:
 Tom's father Ivor and his partner Shirley
 Tom's children James (age 7) and Sophie (age 5 bridesmaid)
 Brother Rob with his wife Julia and son Oliver (age 2)
 Brother Peter
 Grandpa Jo and Nanny Gwen

3:30 General informal

3:45 The couple Tom and Catherine on their own

4:00 The hens (9) and then the stags (15)

4:15 The entire wedding party
 The all relatives group

4:30 Guests to be seated

7:00 Speeches followed by cutting of the cake

8:00 First dance

9:30 Fireworks

End of photographs
Please note that these are the set photographs, there will of course be many more informal shots taken throughout the day

Photographer's notes:
Tom is shy and doesn't like having his photograph taken
Best man Colin and Catherine's sister Anne will assist with groups
Tom's grandfather is frail and can't walk too far
Don't forget detail of flowers, cake, table settings, drinks, food, etc.
Informal shots of Tom's children
Parking is an issue at church
Wedding co-ordinator at the hotel is Fiona Smyth
Addresses and routes in file
Check for delay due to road works
Collect assistant Jasmine from studio at 9:00

Reconnaissance of the venue

You must go beforehand to look at all the various locations for the wedding, not only to establish where the good spots are from a visual perspective but also to work out how long you will need to travel between venues, consider any parking issues and to establish a bad weather contingency plan.

It's always a good idea to introduce yourself to family or venue managers. Make sure that you let them know you are coming and agree a time that is convenient for them. As well as looking at the venue, this is another opportunity to establish links and do some more public relations.

Some couples may want to meet you at the venue. Personally I prefer not to as I like to view the location independently and consider what potential it has from a photographer's perspective. The couple may have chosen the venue because it has a pretty outlook and they may have a preconceived image in their head of how the final images are going to look. While the location may offer great opportunities and you should definitely include any shots they have particularly asked for, you may have other ideas about what would make a great shot. For example, you may have spotted a plain brick wall that offers more potential for a great image than the picturesque location the couple have in mind.

Looking for the light

You will also need to consider what the light may be like on the day. What is the trajectory of the sun for the time of year? Where will the shadows be if it's a clear sunny day? Always look for good shooting areas that are in the shade. Often weddings are in the summer in the midday sun, which is the worst possible lighting situation. Beware of the shade under trees, as dappled blotchy light is difficult.

It's a mistake to plan a shot in May in a beautiful field with long grass when the wedding is in September and the beautiful field is now muddy stubble. Such changes can throw you on the day so, while it is good to arrive armed with a list of locations, stay open minded. Always try and schedule in enough time to do another quick scan of the venues on, or just before, the day. It isn't always possible, you can't plan it all, but if you can equip yourself with enough information about the day, then finding a solution will be much easier if you encounter a problem.

Unless you are faced with a terrible downpour, don't let rain put you off your stride as it can yield some great shots. Overcast skies generally offer a much better diffused light to photograph people than full sun. If you plan to do some rural shots of the couple, perhaps en route to the reception, make sure the field you saw during your recce will not be ploughed up on the actual day.

Bad weather contingency plans

I dread the rain and working in the UK it's an occupational hazard. Showers and dull, overcast skies I can cope with but horizontal rain and a gale is just not a good look! However, it will happen, the show must go on and you must, under very difficult circumstances, still deliver, calmly and quietly as ever. I generally make it clear that I will not be able to provide as much choice and the entire wedding party shot may have to be dropped from the plan.

Unless it is really appalling weather I always try and encourage the couple, at least, to come outside. I have achieved some great shots in the rain – umbrellas can make fantastic props and if you have everything set up and ready you can whisk them outside for the shot and then retreat back indoors.

Look inside for potential low-light shots, too. Record the available ambient light by either using a long exposure and a tripod or up the ISO if your camera is capable of doing this without incurring too much digital 'noise'. These techniques will also need to be employed if it's a late winter wedding.

4. The Big Day

Before the wedding

I find it helpful to look at the day as a series of separate mini shoots. At the beginning of the day it's a daunting prospect to look through the plan at all the shots you have to cover. By taking each sequence one by one, working through the all-important plan, you can judge exactly how much time you can dedicate to each shoot.

This approach takes the pressure and stress out of it and allows you to work calmly, which will free you up to be more creative and confident with your image making. There will be enough anxious people within the wedding party and they will be put at ease by your calm, professional approach.

I always try to achieve as many of the shots as I can before the ceremony. I will already have in the bag, before the marriage has even taken place, the key individual portraits of the bride and groom as well as other important family and friends and the main detail shots.

This is often the time when you can be most creative as you will have the opportunity to take a little more time over each shot, without all the guests and before the real action starts. Most importantly, it will free up time during the reception for the couple to enjoy with their guests and allow you to spend a little longer on the family groups or on candid shots.

The groom, best man and ushers

Generally, the shooting starts with 'the boys'. I find it is best to do this well in advance, often up to two hours before the actual ceremony and before the guests arrive. You cannot hope to get great shots of the ushers if they are ushering guests, nor can you keep the groom's attention if he is greeting a long lost cousin from abroad.

A word of warning: the boys are usually late, which can be alarming and can throw the whole day out. Stay calm and do what you can in the time, then move on to the next shoot. You can pick up some shots later, but do try to get the groom and best man together.

As they arrive and get themselves together, I start shooting straight away, usually with some detail shots of their buttonholes before they have pinned them on to their jackets. They often don't know how to pin them correctly so I like to help them with this job. It gives you an opportunity to get up close and personal, to share a joke and talk to them about the shots you're hoping to get with them. Gently, but with some assertion, let them know that you are in control of the next 20 minutes to half an hour with them.

After you have done the shots, which if you get it right they will really enjoy, you can show them the plan and give a copy to the best man or family member. This shows them you mean business and you can explain you will probably require some help from the boys at the reception, gathering people together or helping with the bigger groups. Bringing them on side at this early stage will make your job a lot easier and help everything run smoothly.

These subtle communications are so important to employ throughout the day, whoever you are shooting. They enable you to be a truly rounded and professional wedding photographer who people will remember for all the right reasons.

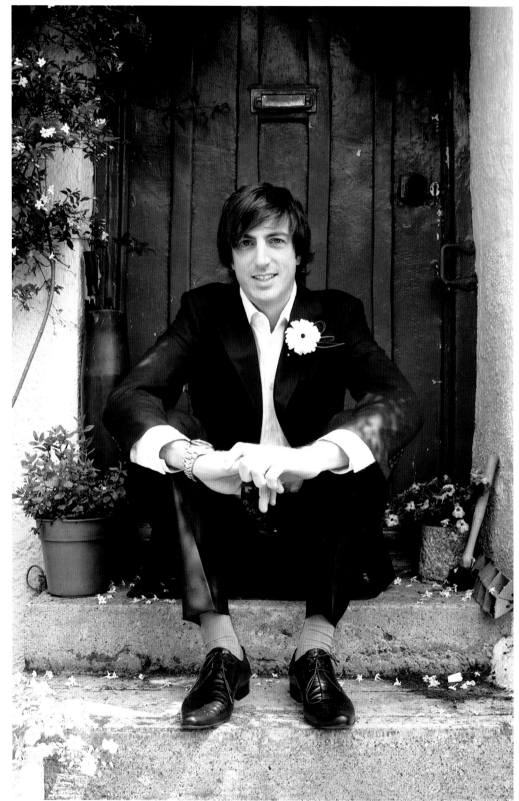

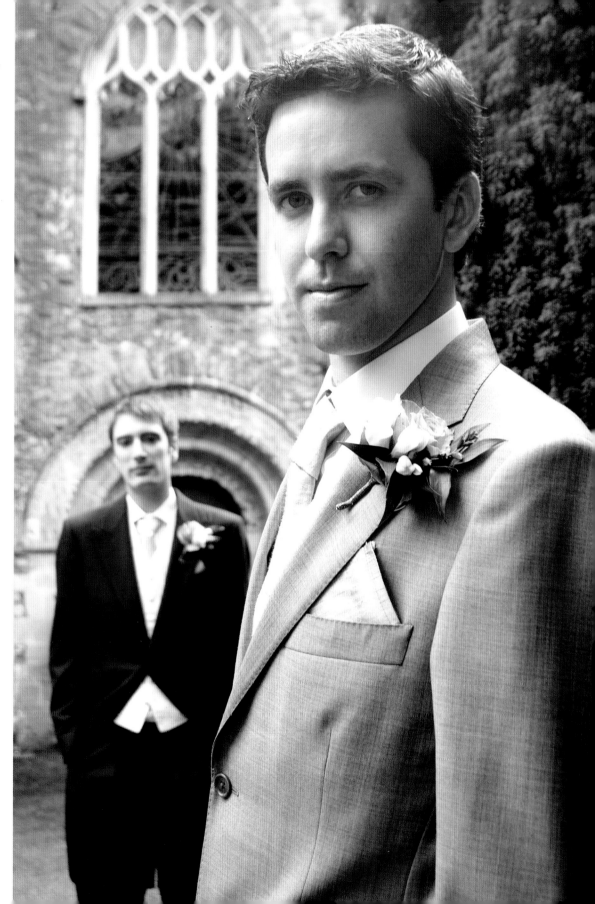

LEFT *On a very bright, sunny day, there wasn't an obviously good location at the groom's house so I set him in dappled shade on the doorstep, shutting the door to hide the clutter inside.*

RIGHT *The groom is usually very nervous so don't take too long or make a fuss about the shots you do with him. I used a shallow depth of field here to make the groom sharp while putting his best man, framed by the church doorway, slightly out of focus.*

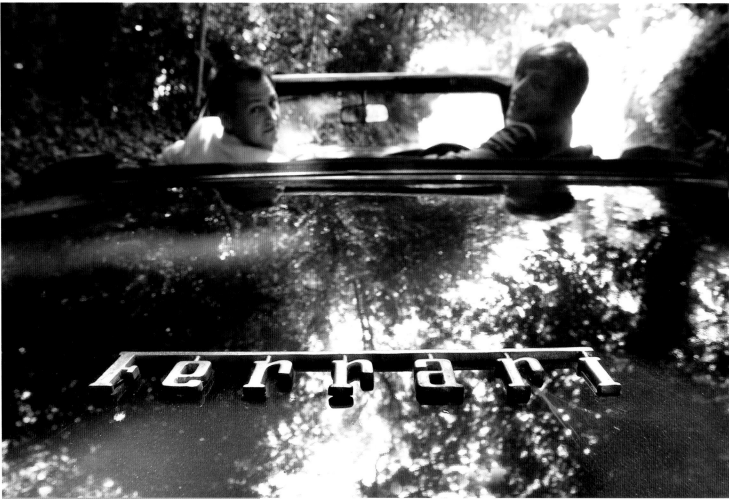

Cars make great props, adding that 'boys and their toys' dimension. This was a particularly lovely toy and I made it the main subject of the picture, keeping the Ferrari name sharp and allowing the faces to drop out of focus. There was strong sunlight with dappled shade from the trees, which is not easy but the reflections on the car work because of that.

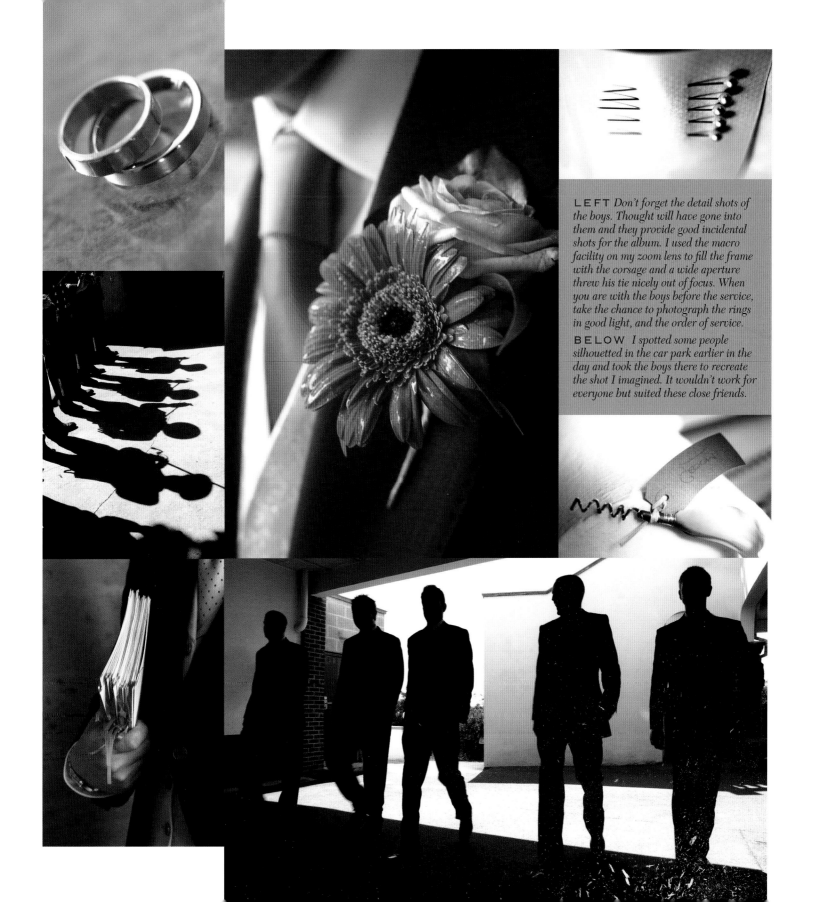

LEFT *Don't forget the detail shots of the boys. Thought will have gone into them and they provide good incidental shots for the album. I used the macro facility on my zoom lens to fill the frame with the corsage and a wide aperture threw his tie nicely out of focus. When you are with the boys before the service, take the chance to photograph the rings in good light, and the order of service.*

BELOW *I spotted some people silhouetted in the car park earlier in the day and took the boys there to recreate the shot I imagined. It wouldn't work for everyone but suited these close friends.*

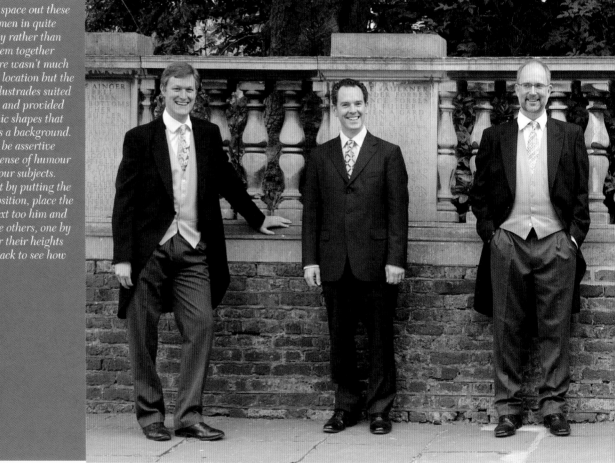

I wanted to space out these eight gentlemen in quite a formal way rather than grouping them together closely. There wasn't much space at the location but the wall and balustrades suited the purpose and provided good, graphic shapes that work well as a background. You need to be assertive but with a sense of humour to control your subjects. Always start by putting the groom in position, place the best man next too him and then add the others, one by one. Stagger their heights and stand back to see how it looks.

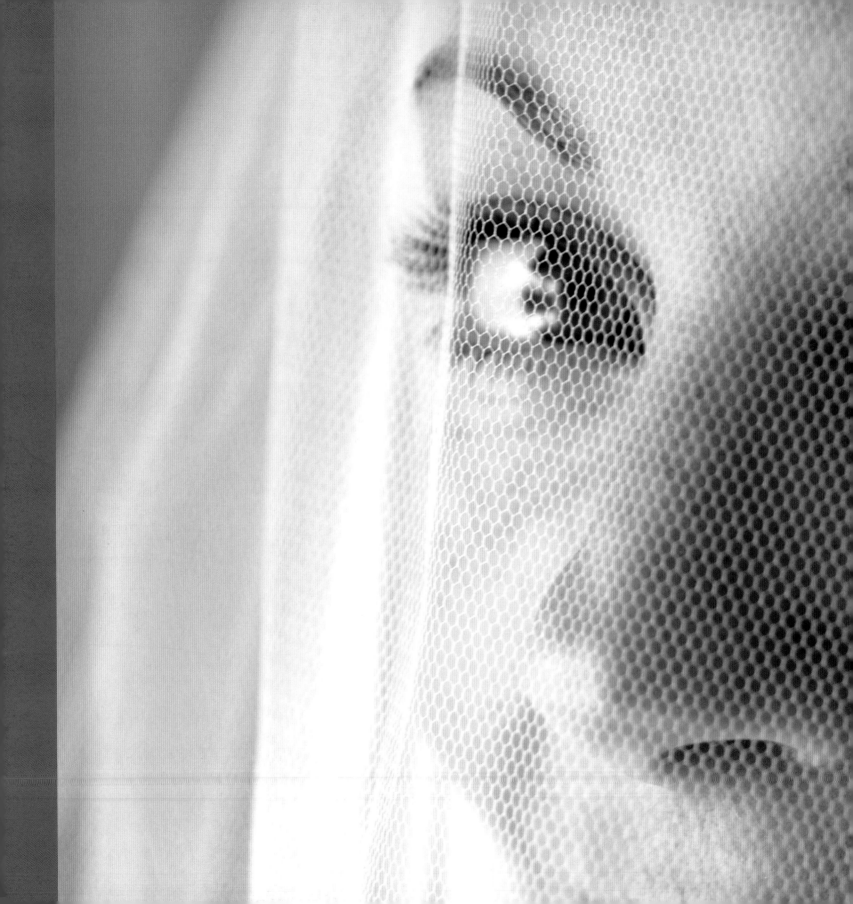

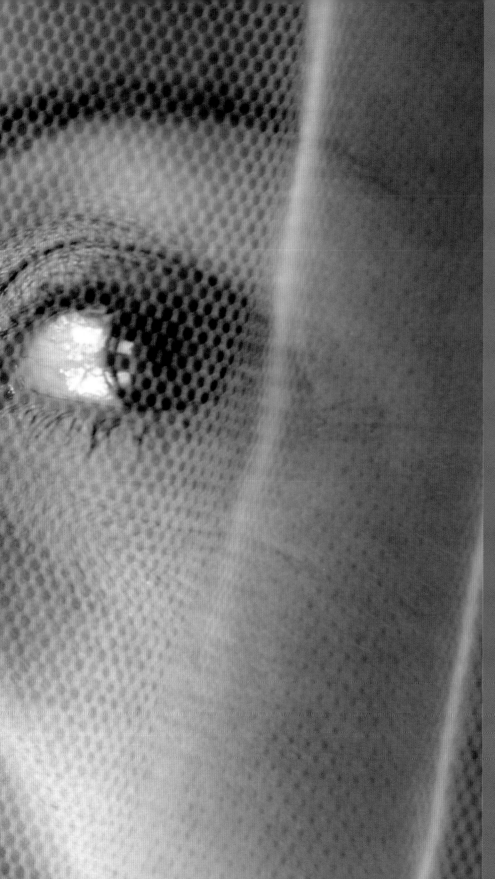

Bride at home portraits

The bride preparing at home will require a totally different shooting and communication approach to the boys. You will be working inside, often in small untidy bedrooms, with many people flapping and getting in each other's way. It's a girl's world.

Remember the bride is the most important person on the day and it's her day. At this stage, just before the ceremony, she is at her most anxious. The best approach is to offer her reassurance coupled with a firm but gentle reminder that you need ten minutes with her dressed and ready before you leave. Lots of other shots can be achieved around her getting ready. Be adaptable and flexible.

The bride may be getting ready at home or at a wedding venue; either way allow one hour not including travel time. There will be great opportunities for some important styled shots and, of course, the key portrait shots of the bride looking at her absolute best.

Often the arrival of the photographer will bring into sharp focus the imminent and fast approaching event and the excitement builds. You will have agreed in advance a time for the bride's hair and make-up to be completed but, just as with the boys, this will often be overlooked and nine times out of ten things will be running late. The bride is rarely ready when you have specified and you cannot put any pressure on her on her wedding day. Remind the hairdresser gently that you will need the bride to be in her dress in good time.

Depending on how much you are planning to do before the ceremony, if it really looks like you are running out of time you will have to get what you can and pick up later in the day. Above all, don't let this put you in a panic; you will have agreed a schedule so you cannot be held responsible if they are not going to stick to it. The show must go on.

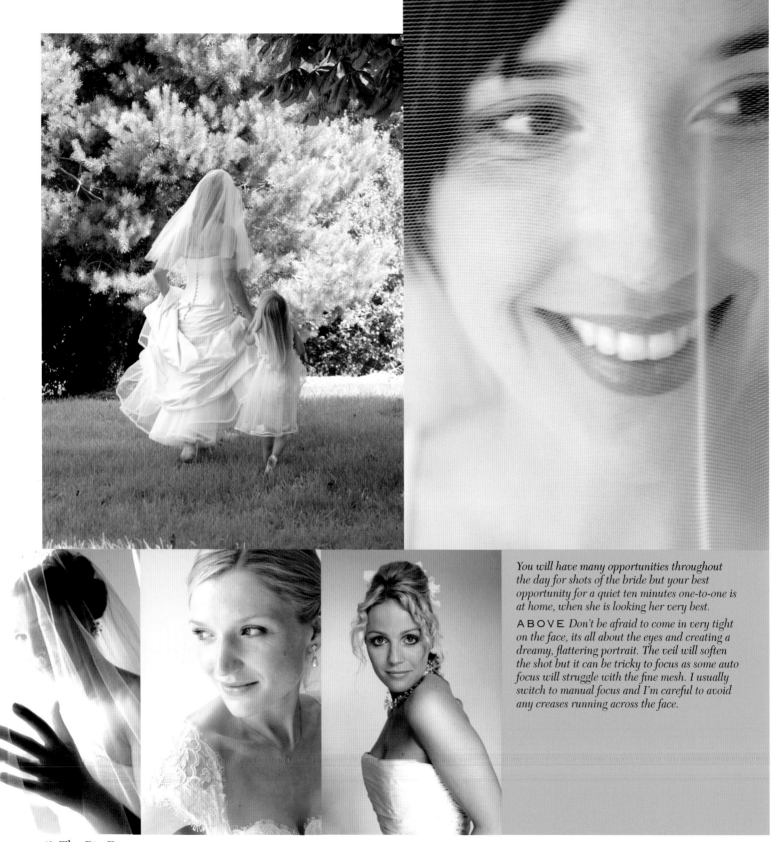

You will have many opportunities throughout the day for shots of the bride but your best opportunity for a quiet ten minutes one-to-one is at home, when she is looking her very best.

ABOVE Don't be afraid to come in very tight on the face, its all about the eyes and creating a dreamy, flattering portrait. The veil will soften the shot but it can be tricky to focus as some auto focus will struggle with the fine mesh. I usually switch to manual focus and I'm careful to avoid any creases running across the face.

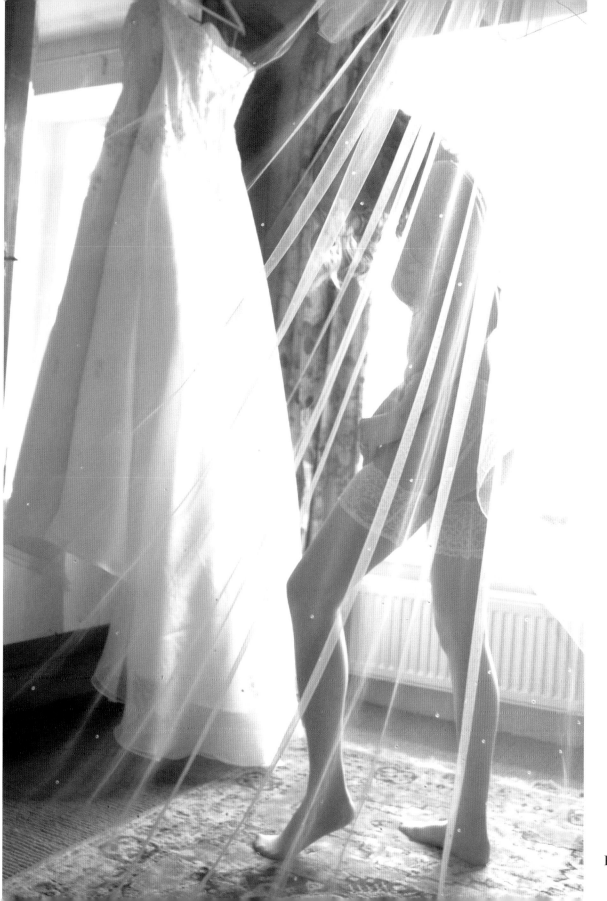

Bride at home candids

Capture the general scene – dad putting on his tie, little bridesmaids being dressed. You will find people respond to being photographed candidly by turning to face you and grinning; well meaning but frustrating when you have crept up to capture a little bridesmaid playing with her dress ribbons. Ask those present to ignore you and not to worry about posing or getting in the shot at this stage. Explain that you are just looking for informal candid shots.

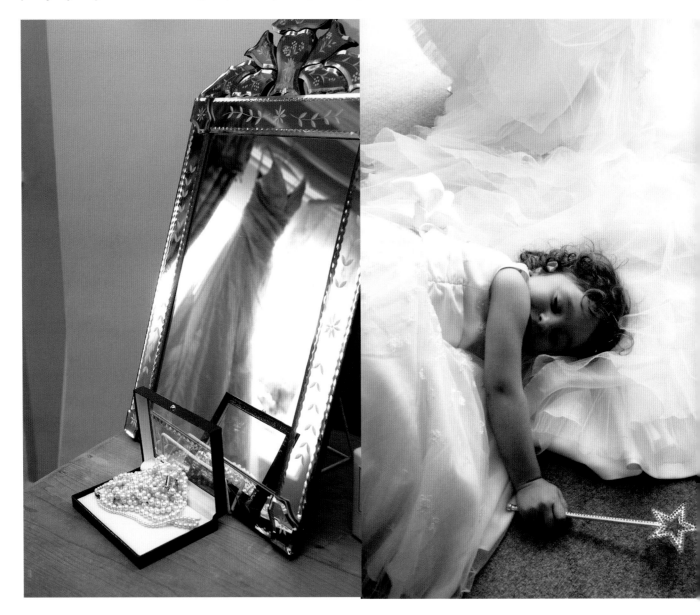

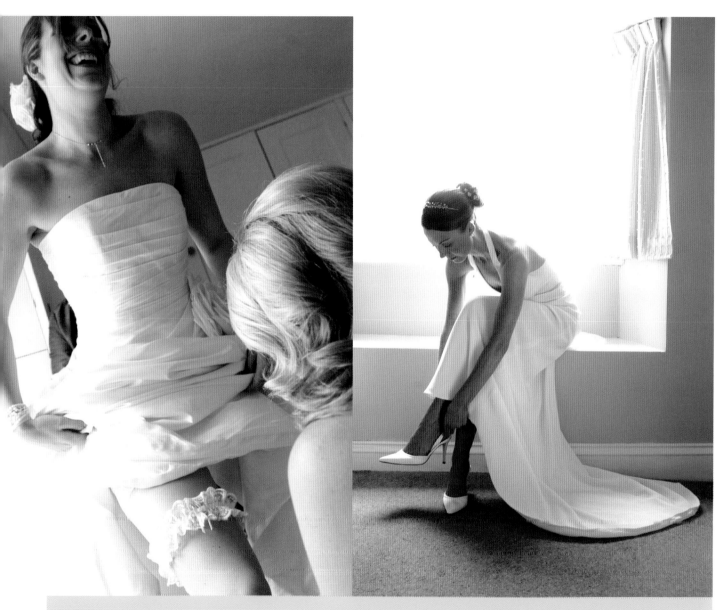

Some dresses look better on than off but if things are running late, you have to work with what is there. The dress on the far left was beautiful but didn't look great on a hanger so I used the pretty mirror and jewellery. The garter shot is a fun, natural moment if you can capture it. However, if you miss something, like the bride putting her shoes on, don't be afraid to mock it up for a second time if necessary.

Bride at home details

The detail shots are so important because this is the bride's finery and so much effort and thought has gone into choosing these things. 'Something borrowed, something blue', sentimental family jewellery, little love notes from the groom, the bouquet, the shoes, the garter – whatever it may be, it's important to record. Also, you will find these shots invaluable at the album design stage. When you have a gap that needs to be filled, a little still life imagery offers some relief from all the people shots, helping with the overall balance of the finished collection.

Don't be scared to move things about if you want a better setting but be careful when handling the precious dress. Clean hands and a quiet mention to the bride that you are going to move it carefully will reassure her. Bear in mind it has been a closely guarded treasure but you still need the shots and will be thanked for them later.

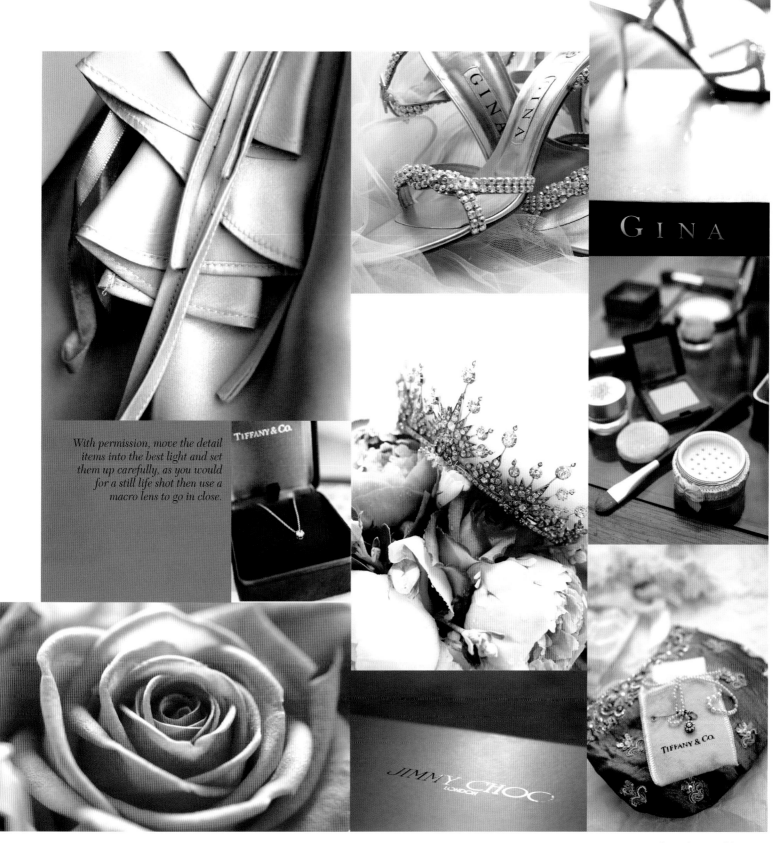

With permission, move the detail items into the best light and set them up carefully, as you would for a still life shot then use a macro lens to go in close.

GINA

TIFFANY & CO.

JIMMY CHOO
LONDON

TIFFANY & CO.

Bridesmaids and bride's mother portraits

If any of the bridesmaids or the bride's mother are ready, try to do some portrait work with them at this stage. Find an area to work in with a clean and uncluttered background with as much light as possible and put each one in the same frame. Keeping things simple makes it less demanding on you and cleaner when you present the finished images. Only attempt these extras if you have time as these shots can be achieved at the ceremony venue, before the bride arrives.

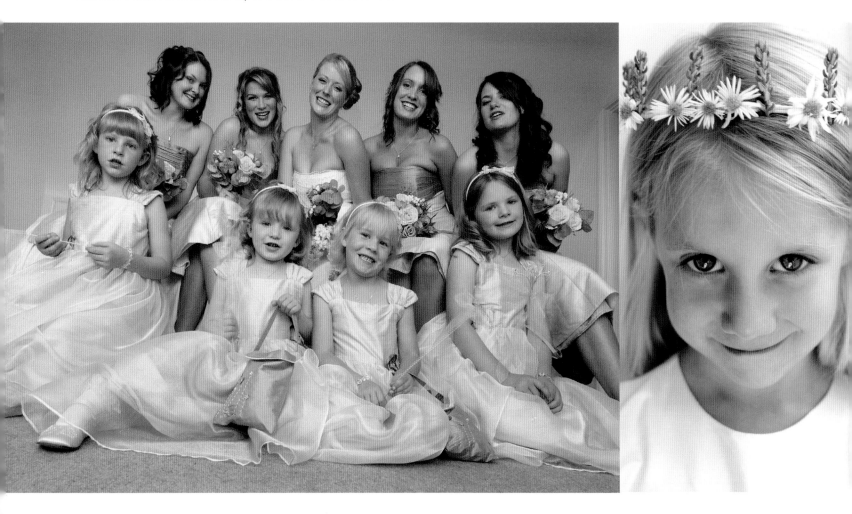

FAR LEFT *There will be other opportunities to photograph the bridesmaids all together but if you can tick it off your list now, so much the better. A bedroom provided a neutral background once I had removed some pictures from the wall.*

LEFT *This little girl's beautiful tiara of lavender and daisies would not stay looking pristine for very long so it was important to capture her wearing it early in the day.*

RIGHT *This is a good example of offering a choice of colour or black and white for the final image. Cropping an image in tight, as on the right, can also provide fantastic results. .*

The bride in her dress

Finally the moment has arrived and the bride is ready to get into her dress. By this stage I have usually arranged things to be placed in the best, lightest room and have done a quick clean up to avoid ironing boards and carrier bags getting in the shot. Usually her mother or one of the bridesmaids will be on hand to help.

Some brides don't mind being semi-naked but it's definitely an advantage to be a female photographer at this point. Generally, though, I retreat to the other side of the door and ask her to come in when she has her dress on but not completely fastened. I manoeuvre her into a good area, by a window or open area, where I can shoot the dressing ritual.

Depending on the dress, it can take some time to button, lace, tweak underskirts, arrange veils, put on jewellery and do up tricky clasps. If things are moving too quickly you can ask the bridesmaid to tie that ribbon again, or the bride to be seated and take her shoe on and off until you have what you need. Be aware of the clock ticking away, stay on schedule, get what you can and leave in good time for the ceremony.

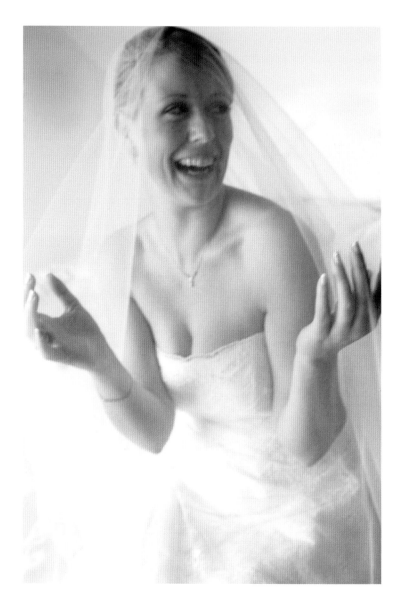

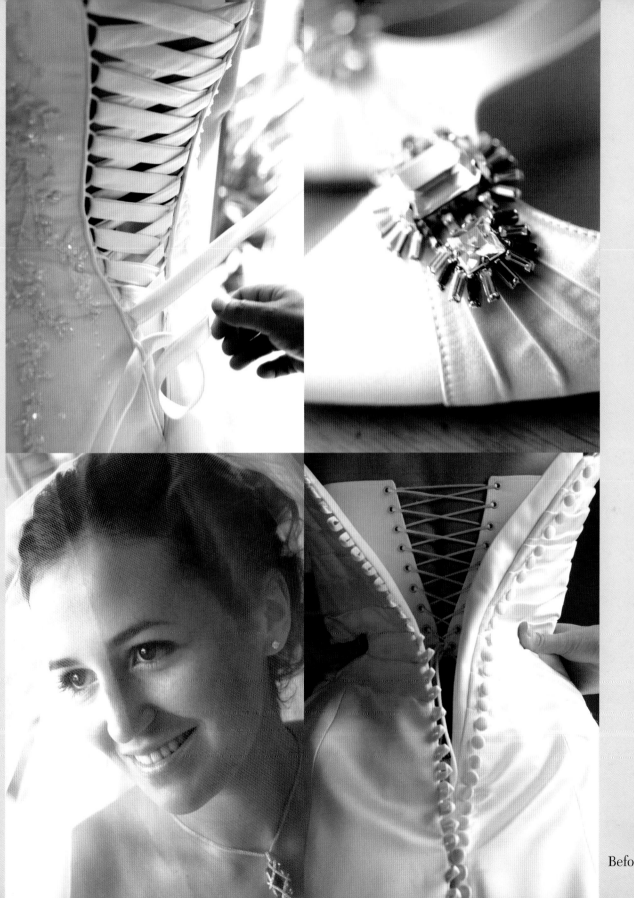

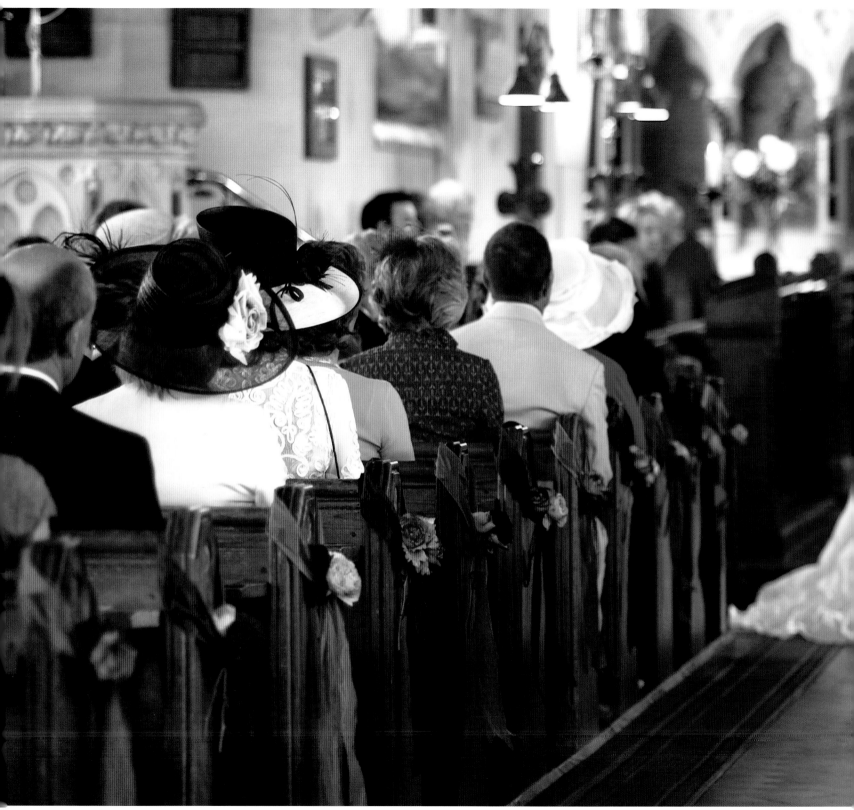

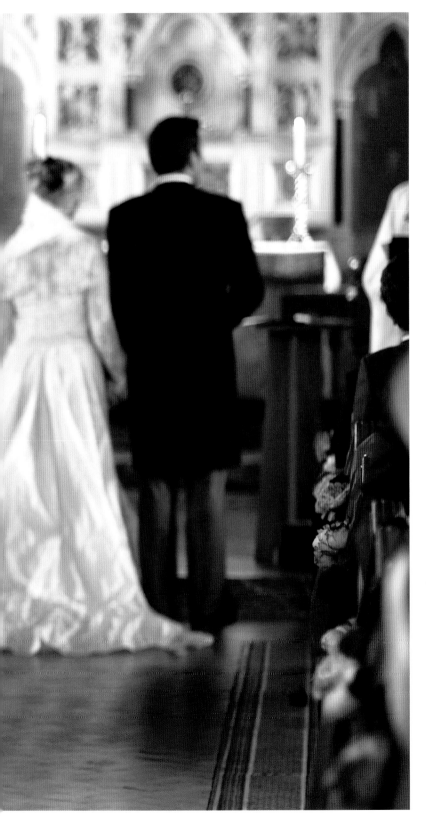

The ceremony

I like to be at the ceremony at least 20 minutes to half an hour before the bride arrives. You will need to park your car, re-group, check your gear, straighten your own jacket, drink some water and put your tripod into position.

Whenever possible, introduce yourself to the official conducting the proceedings. It is important to reassure them that you will respect the ceremony, be very discreet and not distract them or the guests. Use the charm offensive and you will have a better chance of getting the shots you need.

Unfortunately, some officials have had bad experiences with photographers firing flash at inappropriate moments or getting too close during the most sensitive moments of the ceremony. Also, one flash firing can set up a chain reaction amongst the guests for some spontaneous shooting of their own, so you can understand why they may object.

Finding the balance between getting the shots and being discreet is always a fine line throughout the day. Best to meet this situation head-on. Greet the official, shake hands and firmly reassure them that you won't be using flash in any key moments. If you can catch them on the back foot before they have had a chance to say a blanket 'no' to any photography, then you are ahead of the game.

Make sure you have an understanding of the important cultural or religious significance of the particular service being given and what is acceptable to shoot. Certain types of ceremony may require a different approach. These issues are best resolved well in advance.

The bride arriving

When you first arrive there will be a lot of guests arriving too. Find yourself a good vantage point and capture an element of this, as it adds to the whole story of the wedding. Again, don't forget the details like the order of service, confetti baskets and floral displays. If you have had time to get these beforehand, so much the better.

From the point at which the bride arrives to when the ceremony starts is a maximum of five to ten minutes so you will need to work quickly and efficiently. Be ready in the right position for the bride arriving – she may be on foot or in a car. She is usually very nervous and tends to be rushing. I always ask her to walk slowly as this allows more time to frame the shots as she makes her entrance.

There may only be a brief opportunity for a shot of the bride and the person giving her away, generally her father. Make sure you know in advance where you are going to stop them to do this shot. The official is usually there to meet and greet and will be keen to get things moving, so you wont have long.

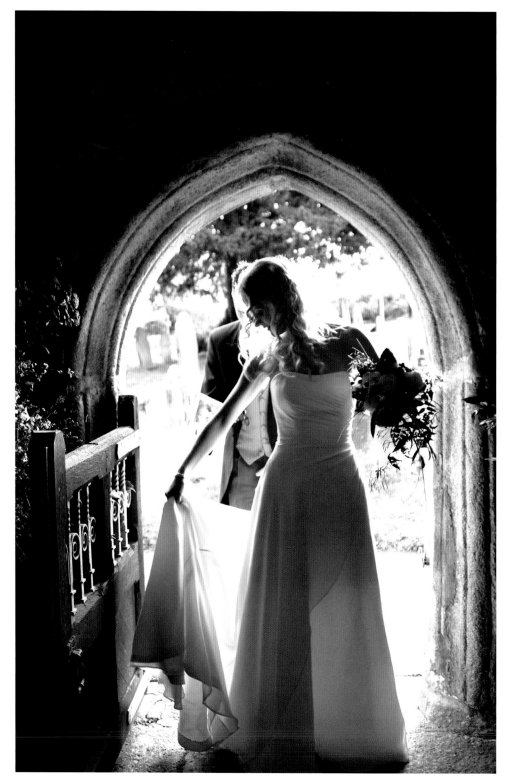

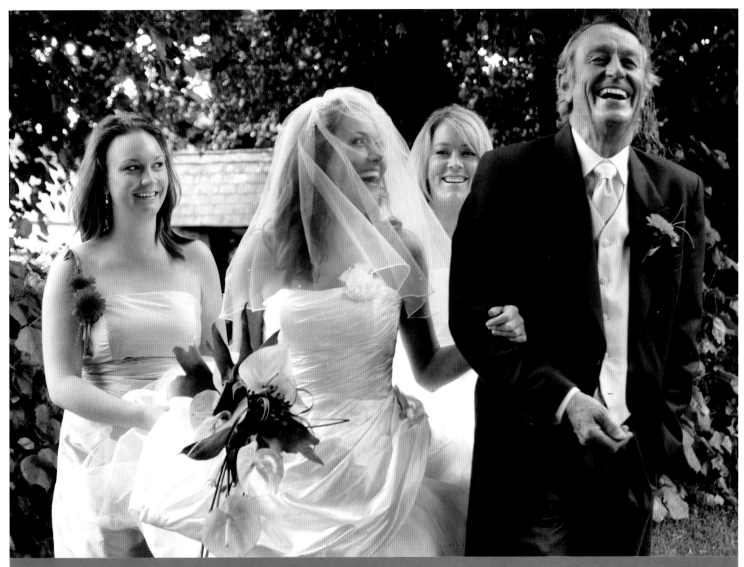

ABOVE *Look to take a formal portrait of the bride and her father but keep your eyes out for spontaneous moments, too.*
LEFT *The strong sunlight reflecting off the flagstones provided plenty of contrast, which shows off the bride's shape and still maintains the detail in the dress.*

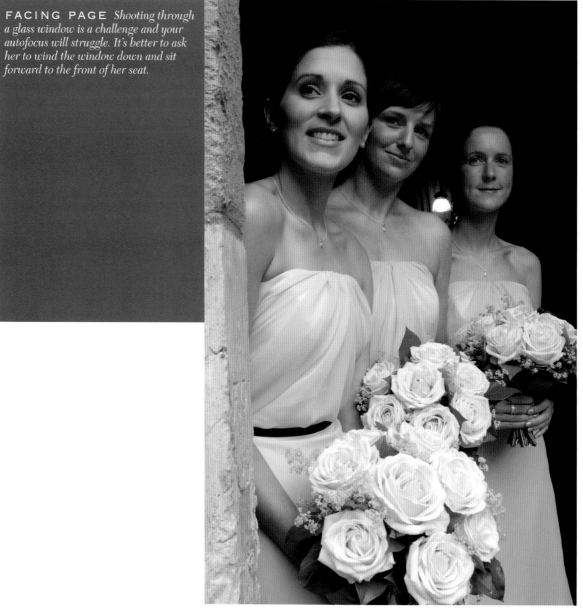

FACING PAGE *Shooting through a glass window is a challenge and your autofocus will struggle. It's better to ask her to wind the window down and sit forward to the front of her seat.*

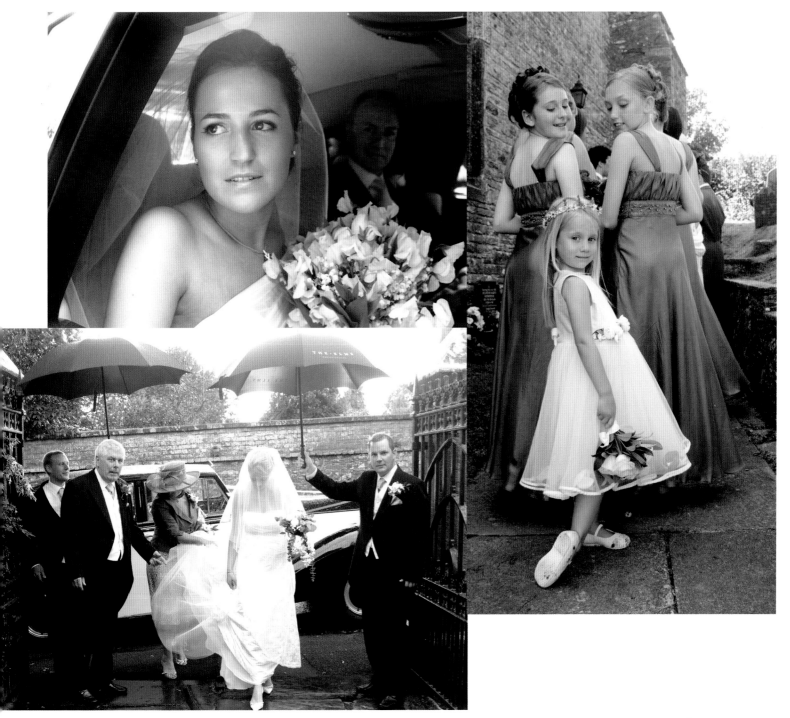

The entrance

The pause just before the bride makes her grand entrance offers good opportunities, such as the bridesmaids tweaking the dress and veil. Often the little bridesmaids and pages are standing in position at the back and by discreetly saying their names, just as they are about to enter, they will turn and look straight at you for great natural shots. As you become more accomplished, you can manipulate your subjects in all sorts of ways into giving you the shots you want.

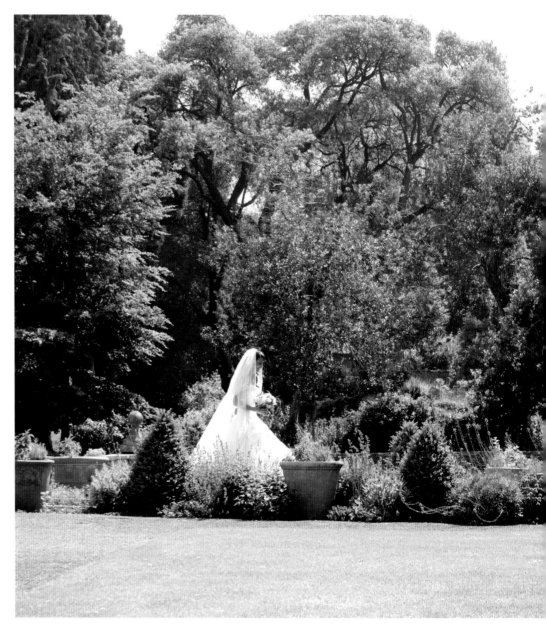

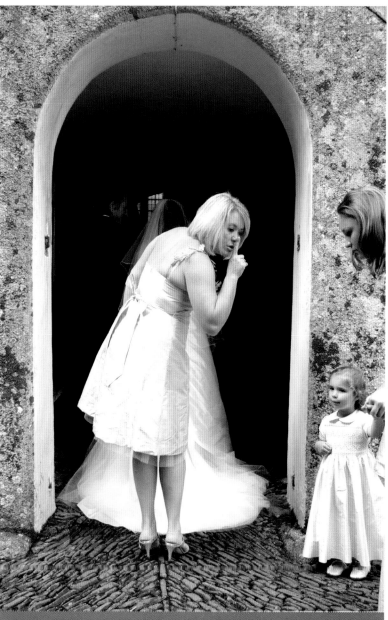

ABOVE *There is a lot going on when the bride arrives and you will find yourself running from the front to the back to cover all angles. If you have an assistant, you can split this job between you.*

During the service

As the bride makes her entrance, you may be able to get in close for the groom's reaction as the bride walks towards him. That's in an ideal world but in reality the location and speed of events can work against you. I feel very strongly that nothing should distract from the couple; you will have plenty of opportunity to get good shots throughout the proceedings without being intrusive. If it's easy for you to get in a bit closer from the side, without distracting the guests too much from the key moments, then do so.

I tend to work with one camera on a tripod, enabling me to work at slower shutter speeds with a long lens. This way I can record all the available light and come in tight for the exchange of rings and the kiss. You should have at least 20 minutes during the service to capture the wider overall scene, as well as covering some closer intimate shots of the vows and rings being exchanged.

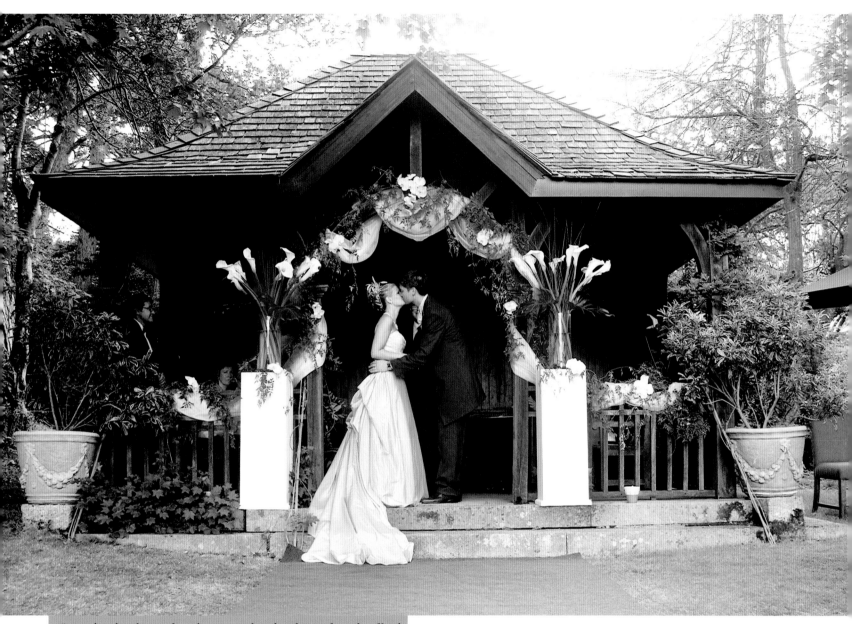

Remember that this is a formal service and neither the couple or the official conducting it will want a lens too close to them at the altar. Stand at the back and use a long lens, or a wide-angle, with the camera on a tripod. You may be able to slip quietly down the side to get a view of the congregation and perhaps the exchanging of the rings but don't attempt to use flash and be aware of how loud your camera is when you press the shutter.

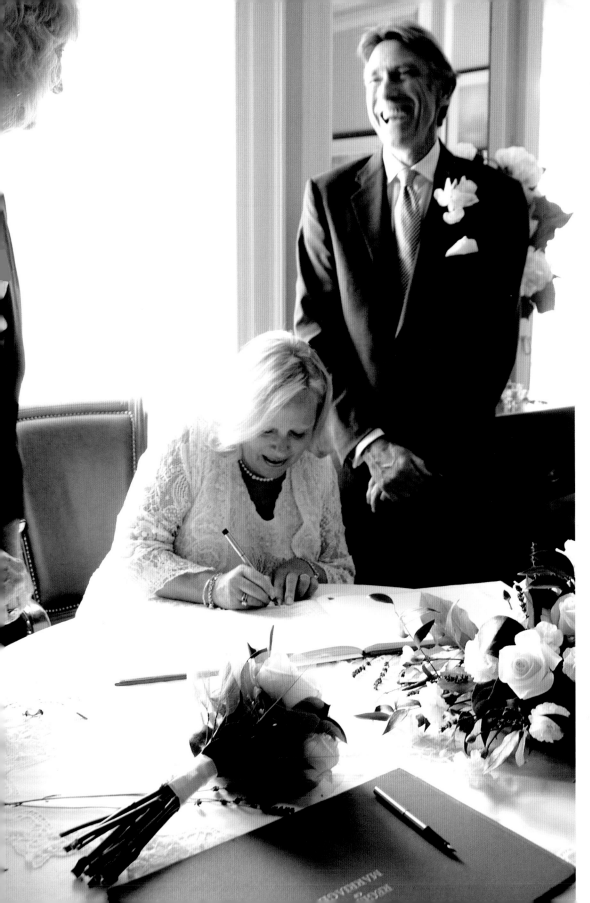

After the marriage

After the ceremony, there is usually a legal document or register to sign. This often involves the immediate family and can be a good opportunity to capture a few emotional exchanges and tender embraces. Again, be careful not to interrupt the official from this important formality. He or she will often stage this procedure for you afterwards, if you ask, and that is worth a few shots, but the ones you capture naturally will be more meaningful and less contrived.

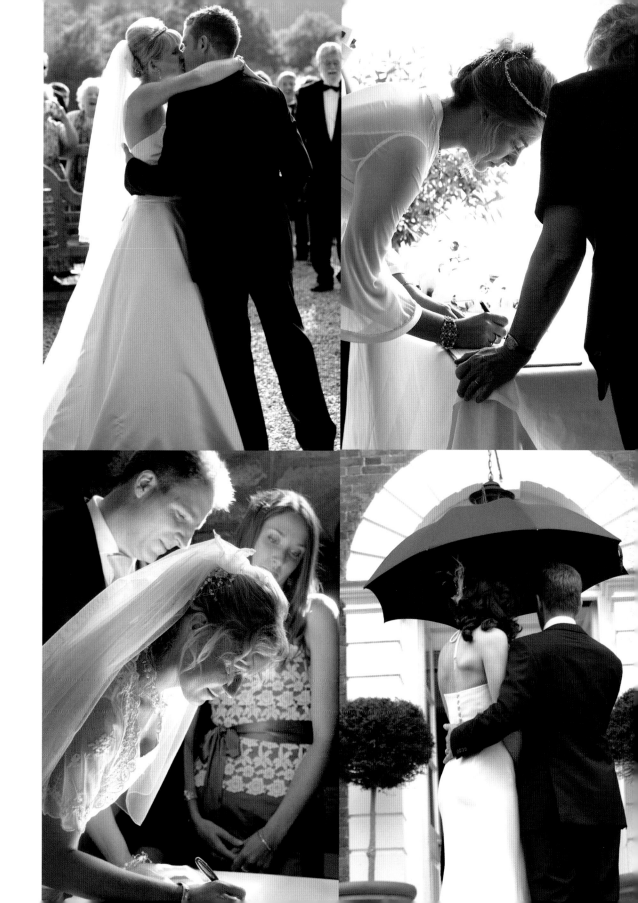

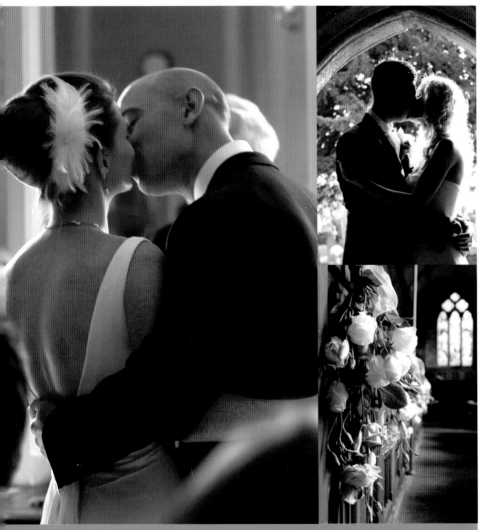

Immediately after the service, the bride and groom will be much more relaxed and you may be able to capture them exchanging a quiet kiss or embrace. The shot, right, was just such a moment that I was fortunate enough to witness.

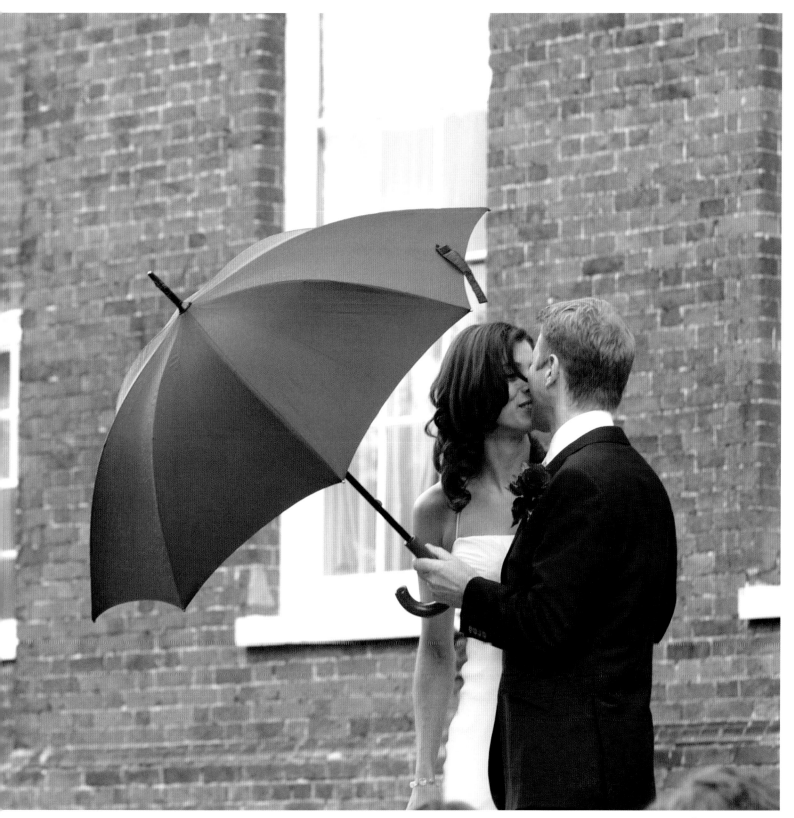

Candid guest shots

Once the couple make the move to leave the ceremony, the relief and joy on their faces is evident. It's time to capture this happy and emotional moment with some spontaneous candid shooting as everyone gathers round to congratulate the happy couple.

Traditionally, the time immediately after the ceremony was given over to the official photographer and some people expect this and hang back. I find this can stall the flow and atmosphere. If people are hanging back, then move the bride and groom into a good position (away from the point at which all the guests are exiting, in case you initiate an informal line-up) and let the guests all take the shots they want of the couple. This will leave you to capture the guests and the overall happy scene and hopefully someone will start throwing the confetti.

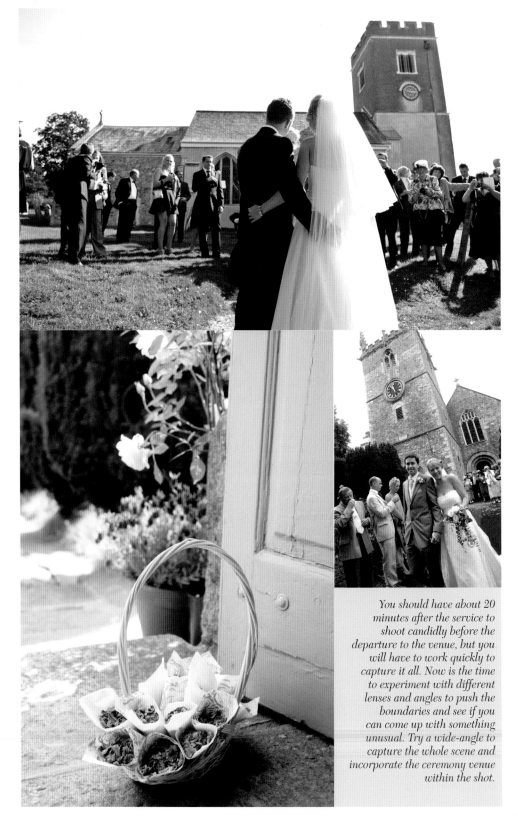

You should have about 20 minutes after the service to shoot candidly before the departure to the venue, but you will have to work quickly to capture it all. Now is the time to experiment with different lenses and angles to push the boundaries and see if you can come up with something unusual. Try a wide-angle to capture the whole scene and incorporate the ceremony venue within the shot.

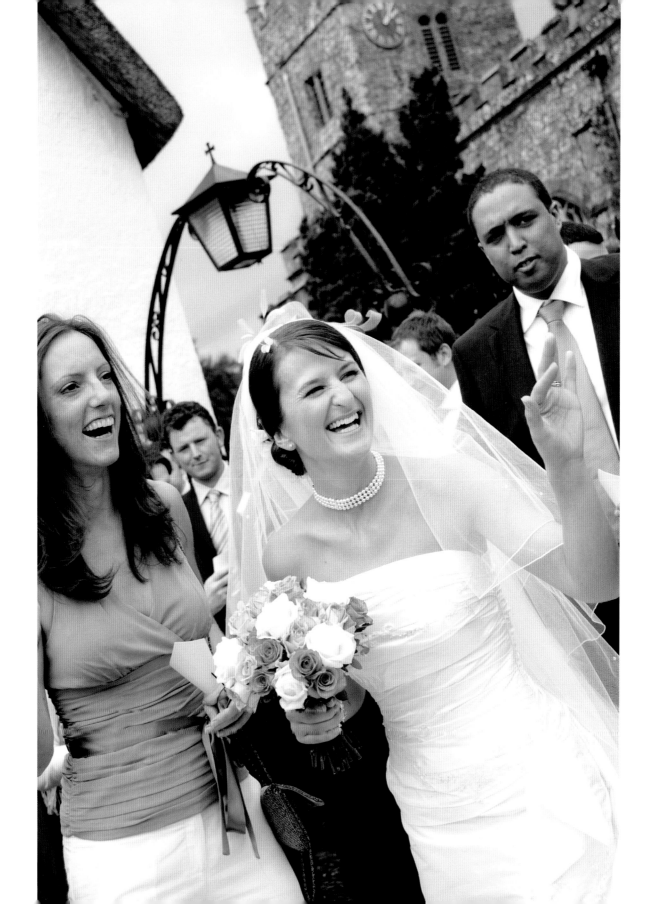

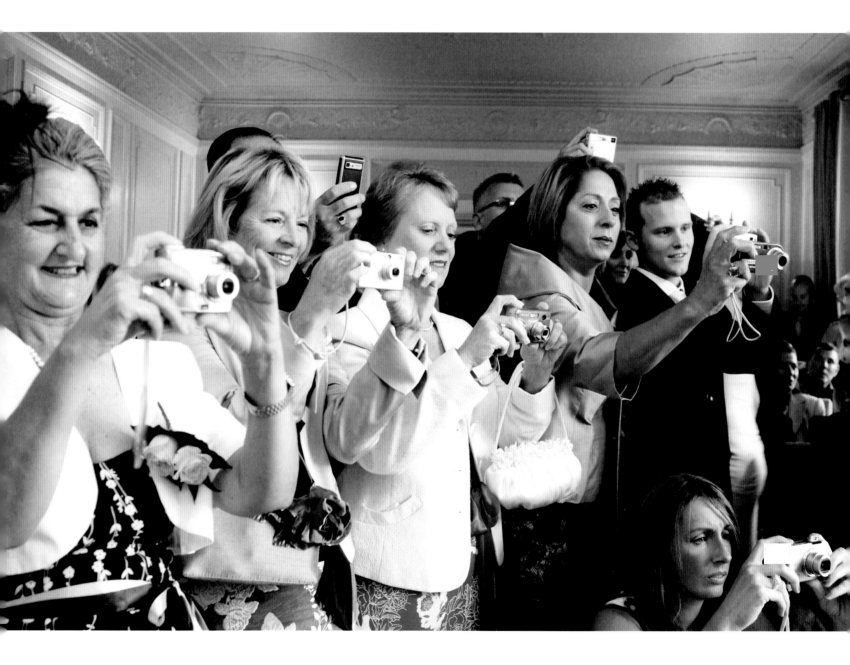

FACING PAGE *Everyone has a camera these days and I like to get in the way and photograph them. It often causes a laugh and creates a great image.*

TOP LEFT *Always look for the characters at the wedding and interact with guests to get the best shots.*

ABOVE *It's important to be ready for moments such as when the bride throws the bouquet.*

Confetti shots

Some photographers will set up a confetti shot but I prefer to let it all unfold naturally as I think it can look and feel a bit contrived if it's staged. However, if it's something that the couple have specified and the location is suitable, try and arrange the guests all to throw it at once with the couple in position.

You will need to be assertive to move people into the best places and orchestrate the guests. Sometimes this approach can be useful if the crowd are a little reserved and need a bit of coaxing to initiate the end of the formalities.

Spontaneous or staged, confetti shots are not easy to get right. Sometimes guests will throw it and the wind will carry it in the opposite direction, or the more reserved guests will be unsure of the right moment. I always try to throw a bit myself to start things off and ask for some of the guests or little ones to throw some at me, which can yield a fun, lively shot.

If the wedding party is moving on to a different venue for the reception, be mindful of the time. The couple and family will be so swept up that they will have lost all track of it and often the photographer will be the only one at this point trying to keep to schedule. You can give them a gentle nudge to get them moving or ask one of the ushers or bridesmaids you met earlier in the day to help.

It is in your interest to have things running on time as you still have all the shots on your plan to achieve. If the wedding is at a single location then you will probably have the advantage of the wedding coordinator running the event and it will be less of an issue.

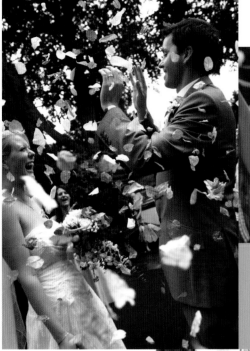

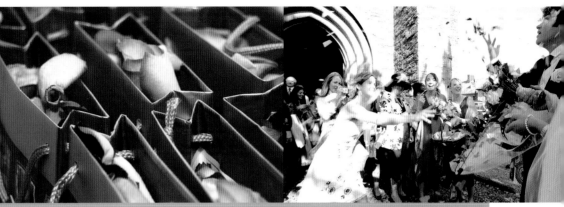

LEFT *Confetti shots lend themselves to conversion to black and white and then subtle 'hand colouring' of the petals in Photoshop. Experiment with different shutter speeds to freeze the action completely or allow some movement in.*

BELOW *Confetti guns are great fun. These boys were enjoying playing with them and I just had to sit them on the car and tell them to fire at me.*

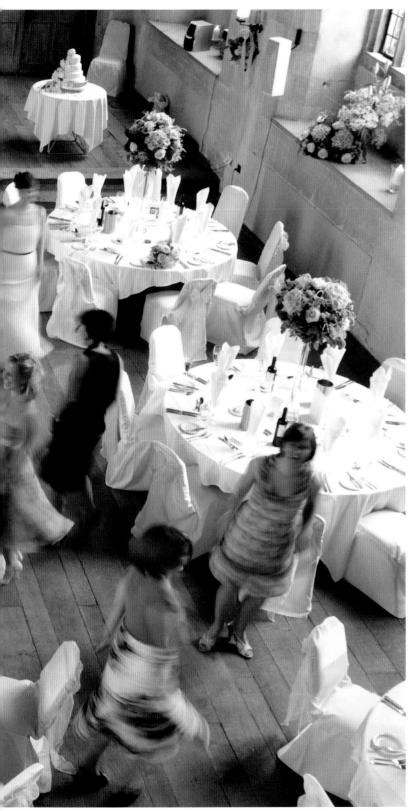

The reception

The time between the start of the reception to when the guests are seated for the wedding breakfast varies considerably. Sometimes you may only have one hour, in which case the couple should be prepared to devote virtually all of it for you to cover the shots that they will invariably have on their wish list. I recommend two hours so that you can break any set photography down into 10 to 15 minute segments. In the meantime the couple are free to enjoy the party with their guest and you have a chance to record as much as possible, shooting informally.

Ultimately you want to present the couple with a record of their day and that must include those priceless, candid moments as well as the listed shots. There is much to include during the reception, from all the set groups and candid portraits to details of the cake, food and decorations and then the speeches and cake cutting.

The order in which you cover some or all of this and how many different set-ups you need for each subject will depend on the type of wedding and the time available to you. You may choose to do some of the groups, such as the couple with bridesmaids and best man, immediately after the ceremony rather than during the reception. If location or timings work better that way, then why not? The pros and cons of all this should all be worked out and agreed well beforehand.

Arriving at the reception

On arriving allow 15 minutes of informal shooting. The guests can have a drink and familiarize themselves with the surroundings, finding out who they will be seated with and so on. Often the bride will disappear to powder her nose and there will be a general settling in period. I usually try to get some details shots of the cake and table settings and maybe some informal shots of the little bridesmaids and pages running about, freed from the constraints of having had to behave for so long. You must make the most of every moment available to you.

Sometimes, if the wedding is a formal affair, there will be an official receiving line. This can take place either at the beginning of the reception or as guests are being seated. From the photographer's perspective, the line-up is a dreaded affair when your key people are tied up meeting and greeting their guests for up to an hour or more.

Thankfully most couples recognize that this formal tradition can be re-worked later in the day. A line-up can be moved through much faster once most of the guests have had a chance to say hello to the couple and family during the reception.

As an alternative option, I often suggest that the couple make a point to go to each table in turn during the wedding breakfast. It's important that all the guests have an opportunity to speak with the couple, which is why the formal line-up evolved. It is often the parents at a traditional wedding who want to uphold this formality. All you can do is make the couple aware of how long it can take and that it will eat up their valuable time for photography.

If the couple have gone to the trouble of organizing any special modes of transport for themselves or their guests, make sure you record it. This was a smart London wedding and the guests arrived at the reception in a traditional red London bus.

Venue shots and details

When the couple first arrive at the reception, ask them to stand in the best possible position from your point of view, an open area with good light and a clean background, as the guests will congregate around them. You won't always have control over it but at least avoid them standing in the car park!

You should have some time at this point to go into the marquee or dining area to photograph it while it is still untouched and looking its best. As well as wider shots of the room and table settings, go in close on the flowers and wedding favours. Use a macro lens and over expose by one third of a stop to make the whites of plates and linen look cleaner.

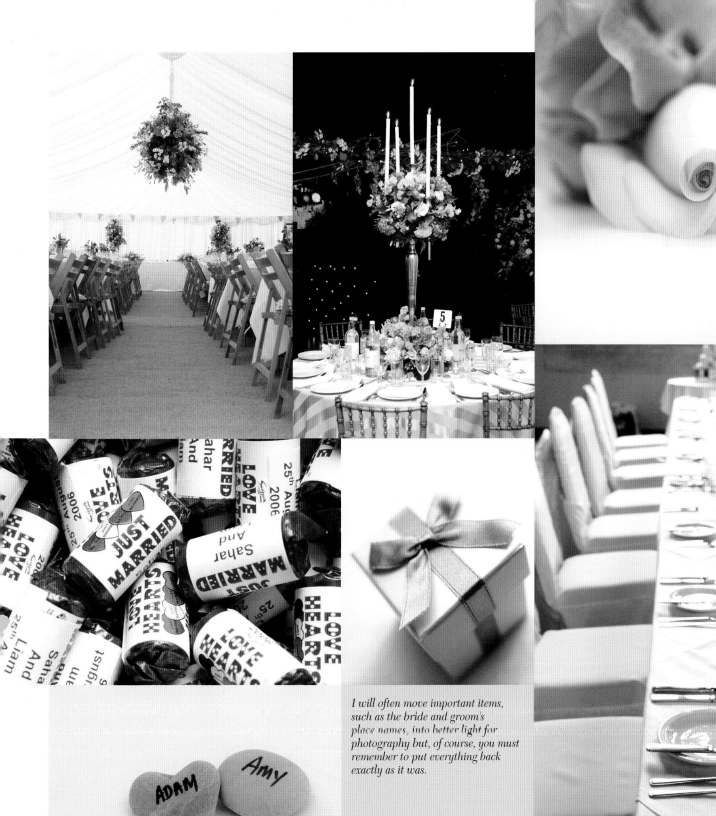

I will often move important items, such as the bride and groom's place names, into better light for photography but, of course, you must remember to put everything back exactly as it was.

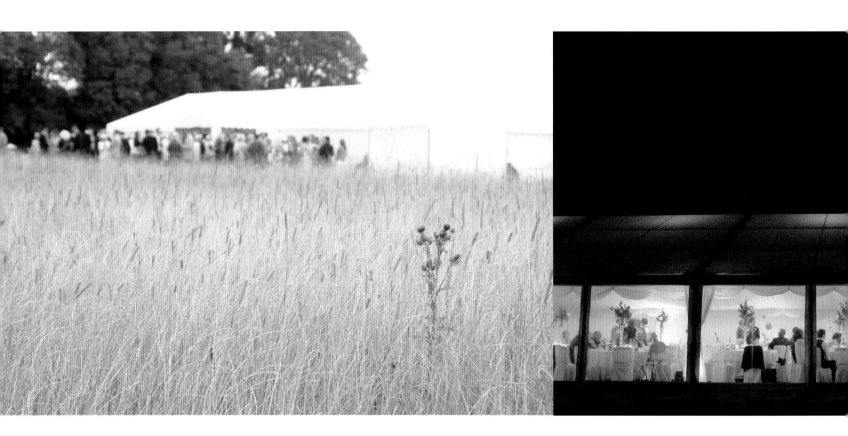

Walk away from the throng of people, or wait until they are seated, eating, to see the venue from a different perspective. Interesting, quirky shots will make your work stand out so always look for unusual angles. You could also try different lenses, take a low viewpoint or ask permission to shoot from an upstairs window. In the evening, use a tripod and long exposure to record the ambient light or try fill-in flash. Being creative and pushing the boudaries is more important than having every shot technically perfect.

Candid shots of children

Shooting candidly is an ongoing job throughout the entire day and you need to have eyes in the back of your head. Look around you all the time and try to predict what might be happening next. If you see something interesting going on, get involved and be prepared to intervene to get your shot.

You should have allotted some time in your plan to work with the key children at the wedding. Try to engage them in a game or activity, a running race or picking a flower, rather than trying to pose them as they will bore of that very quickly. You will achieve much better results shooting them while they are having fun. Children are unpredictable so always be prepared to grab shots as events unfold.

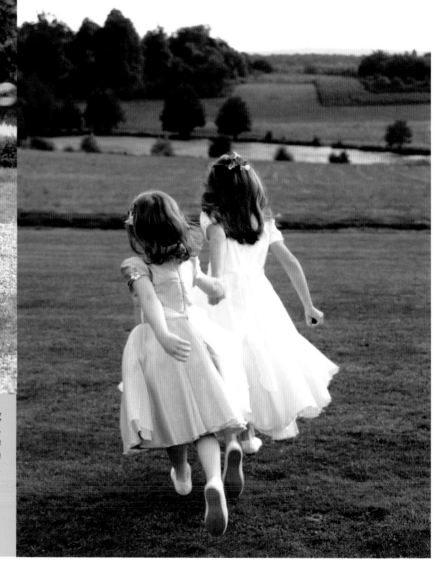

You can often make shots happen with children by instigating a game. If you ask them to run down a hill holding hands, they will set off like clockwork toys. It's more fun for them and you will get better results than a static pose, which anyone with a camera could take.

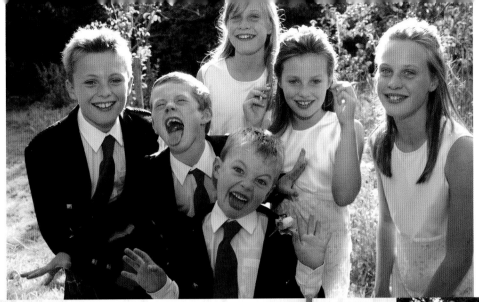

Group shots

You will no doubt have quite a number of groups to photograph throughout the reception, whether they be family, other key people or friends. I will always recommend couples keep any set groupings to the bare minimum to allow more free time to shoot informally.

Although the aim is to make the set groups look as natural, relaxed and informal as possible, with the best will in the world, stage management has to be employed for all of them. How else can you get the correct people all looking good in your viewfinder if you don't take that approach? The skill is to get them all together in the same place at the same time, without too much fuss and arrange them to look like it fell into place by itself.

The more formal family groups with parents and grandparents will require a totally different approach to, say, a grouping of girls for a hen party shot. With the latter, you have more licence for getting them moving and laughing or placing them in a more radical location.

Ideally you will have narrowed down the family groups to the essentials and immediate family only. You will have a very specific list of names and their relationship with the couple, highlighting any sensitive issues between family members. A spare plan will already have been given to a key member within the bridal party and you will have decided exactly when and where you are going to gather and shoot everyone.

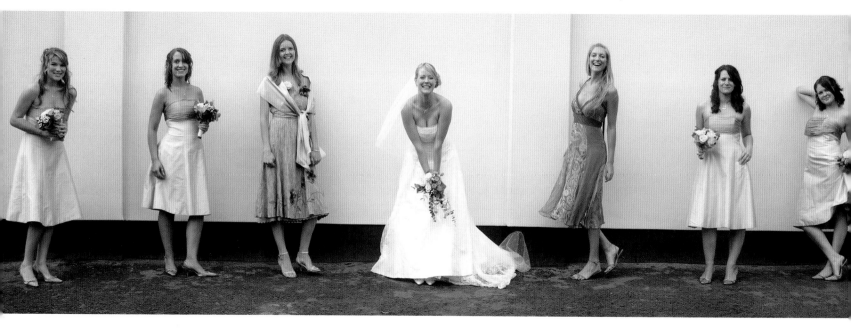

Working with the location

Your location for the group shots will have been checked out at the reconnaissance you made before the wedding. I always make sure I know how many people I have to place in a group beforehand and number them on the plan so I know there will be adequate space for everyone. You do not want to be relocating groups once you have them all gathered.

If there are elderly people who are not fit and able, they will not want to walk too far from the main reception area but, equally, there should be enough distance to give the family some privacy. Most people are very self-conscious and not keen on being photographed and having an audience can make them feel even more uncomfortable.

Benches, seats with arm rests and steps are all invaluable props for the more formal family groupings. They enable you to place people at different heights and it's more relaxed for them than standing. Any more than seven or so people in a group and it's difficult to get an interesting and successful standing composition without it looking like a line-up. Don't worry too much if the bench is not that pretty as the frame will be mostly filled with faces and people, but do have a blanket to place on a bench, to protect dresses from getting dirty.

LEFT *This was taken by my assistant as the group was looking up at me. It's often possible to get better shots this way than from straightforward grouping. The 45-degree angle is very flattering and creates a lovely study of the faces, despite the difficult lighting we were working with.*

Organising the groups

Give your allocated helper (whether it's an assistant or a member of the bridal party) a 15-minute advance warning, and ask them to gather together all the people on the list at the agreed location. It will then become clear who is missing – and there are always a few – a sister feeding her baby or, more likely, dad at the bar. Make sure it is someone not required in the shot who goes to retrieve him or the whole affair can descend into chaos. Leave the couple last on the list, so as not to disturb them from the party and their guests.

Any wedding photographer will tell you that organizing the family groups is always a bit stressful. By being firm and in control you can get through it without having to be too bossy and the whole roll call approach can be avoided. You will need to check names once you have the family gathered, but at least you can do this individually rather than making the entire wedding party feel like they are back at school.

Make sure you have some wider full-length shots as well as tighter ones and keep an even balance between the bride and groom's families. As you have the most important people in one place there will be opportunities to grab candid head shots on the side, some of which will be much more meaningful than the formal poses.

Pay particular attention to the parents, aiming for a casual shot of them together at some point. Make a fuss of them; it is such an important day for them and they are your customers as much as the bride and groom, particularly if they have paid or made a substantial contribution.

Often there will be requests for additional groups of extended family, cousins or aunts, over and above those on your list. Usually this comes from one of the mothers. Explain politely that you must keep on schedule but if it is possible to squeeze in any extras you will. You can suggest that if they want to gather the people together you will shoot them informally but you must carry on with your plan. Try not to bow to pressure. Explain tactfully that the couple wanted to include everyone but there just isn't time to cover all the extended family and only essential groups are included on the list.

If it looks like this may be a problem, suggest doing a group of all the relatives as an additional shot when (and only if) you are doing the entire wedding party. That way you can avoid doing lots of extra, unplanned groups while placating a disgruntled aunt who may be feeling left out. Remember, family politics are often bought to the surface on the day.

Once you have these shots in the bag, let the couple rejoin the party as soon as possible and prepare to set up the next shot.

The couple

At whatever point you do these shots, whether it's before the guests have arrived or while they are being seated for the food, the more time you have alone with the bride and groom the better. Some couples will be more than happy to give you up to half an hour but others either won't have the luxury of that much time or simply won't want the fuss. Either way, it's in your remit to make sure that you have a winning shot of them together.

If you are really up against the clock, remember that you should by now have captured a lot of candid images of them together and what you are after now is to make a few more images of them under more controlled conditions.

It is best to take the couple some way away from the party. A few people usually want to come along and get some shots of their own so politely ask them to give the couple a bit of space. The couple will really appreciate being out of the spotlight for a short while and it's easier for you to ask than it is for them. From your own point of view, no matter how well meaning the keen guest snapper may be, they will invariably get in the shot or distract you from some of the most important work of the day.

Take the couple for a quiet walk. Hang back to give them some space and take some longer shots of them full-length, hand in hand from the back. Ask them to stop and face each other for a kiss and a cuddle, ignoring you and just enjoying a little peace and quiet together. More often than not you will find you can capture some genuine and unstaged tender moments with a long lens.

By shooting from a distance and backing off a bit, you will have warmed them up to the idea of being photographed. Some couples will have no problem with this and will be the perfect models but often you will have to offer very clear and concise direction as to exactly what you want them to do for you.

You will have dealt with the principal, individual portraits of the bride and groom before the ceremony but don't let the opportunity pass you by to capture some additional shots of them alone during the time you have with them together. It's good to be able to offer them as much variety as possible and at this time, even though the hair and make-up may not be perfect, they will both be very much more relaxed. The locations that you have scouted should offer you some backgrounds and settings that you can include in the finished collection.

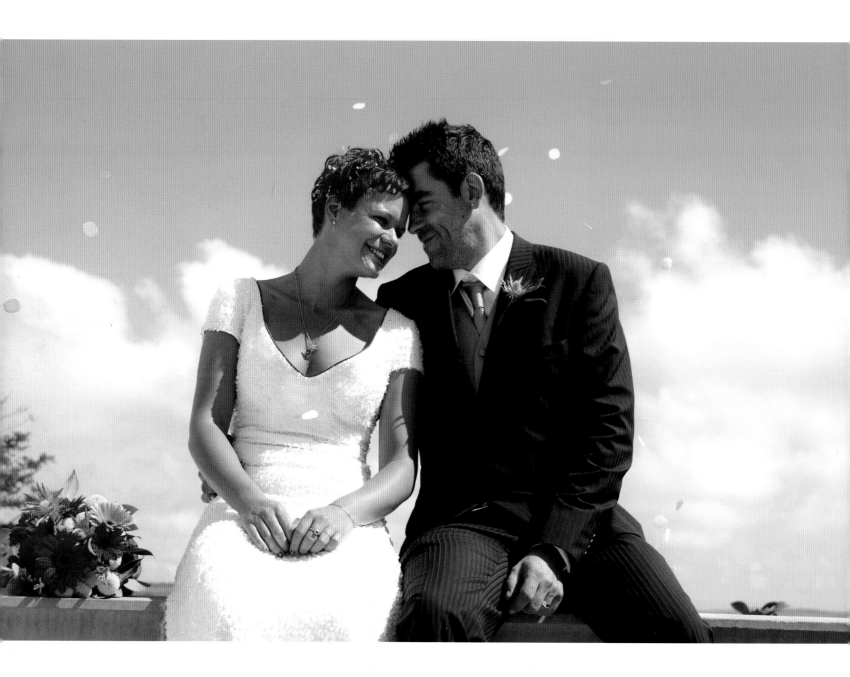

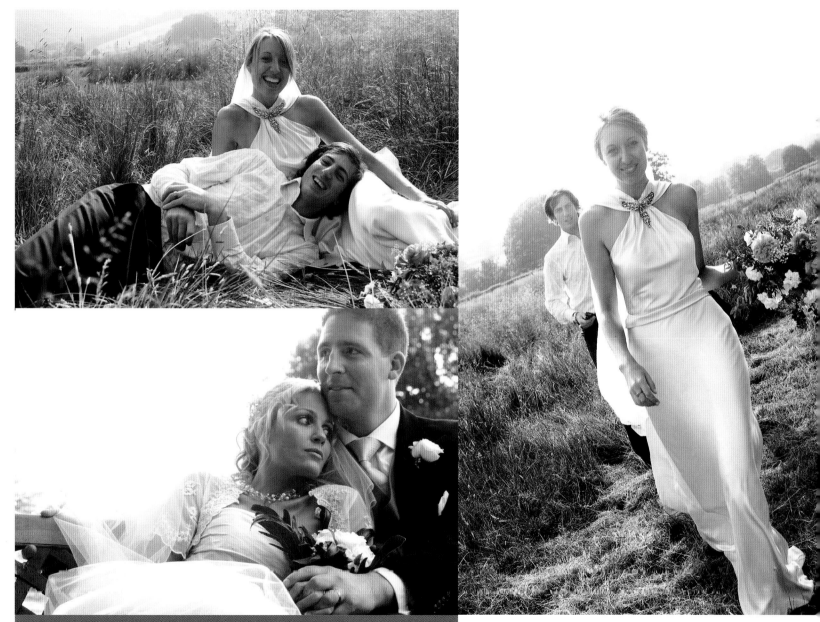

Think about your backgrounds when photographing the couple. You could go for something quite graphic or something as neutral as the sky or grass. If you have a good, rural location, take them for a walk, sit them down, not too close together and ask them to lean into each other. Take account of their heights. If you have a really tall groom and short bride, or the other way around, you will need to find a way to balance them out.

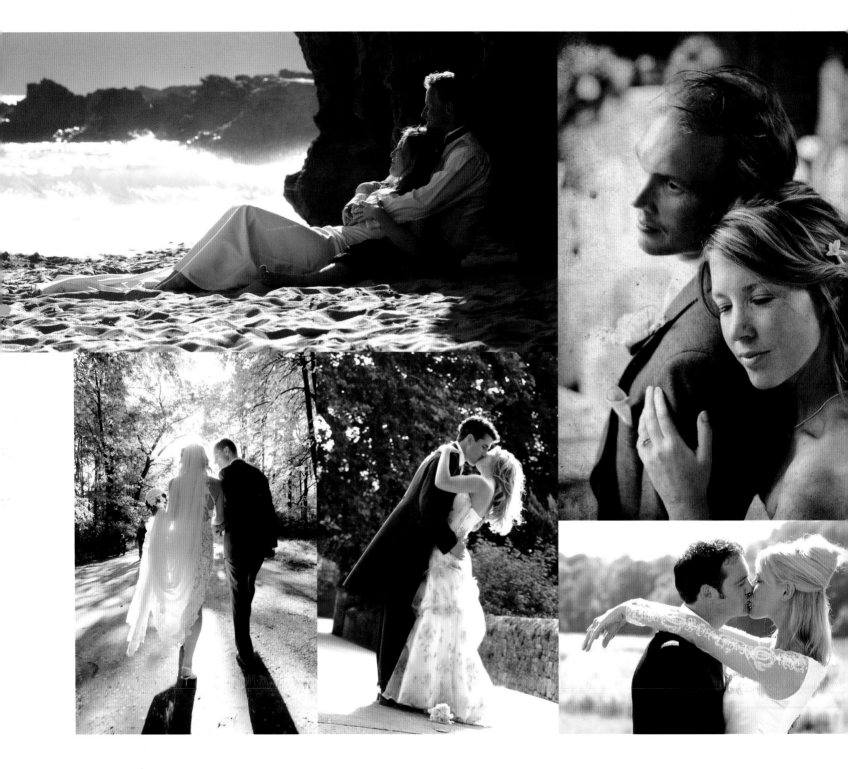

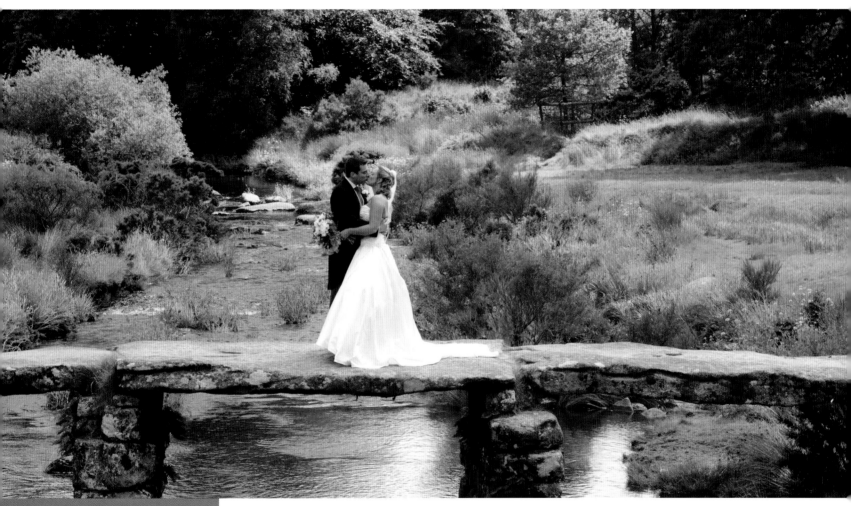

Practise on a couple of friends to build up a repertoire of posing techniques and work on speeding up so you can set them up quickly. What will work with one couple may not with another, which is why it is worth offering a free engagement portrait session.

Take individual portraits of the bride and groom during this time, as well as shots of them together. When you have most of the formal shots out of the way the bride will be much more relaxed and not so worried that her dress or veil are perfectly in place. You can use the veil to get her moving a little, twirling round and shooting through the veil. Make it a really good experience for her to enjoy wearing her dress and you will be rewarded with lovely, imagery.

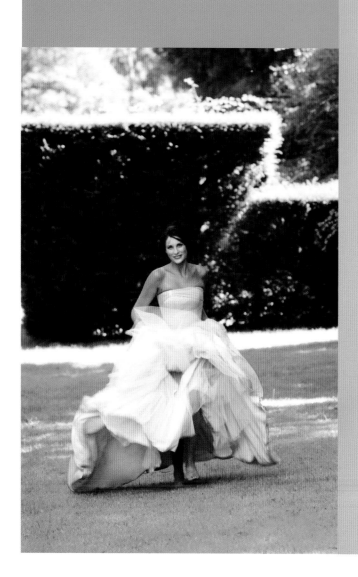

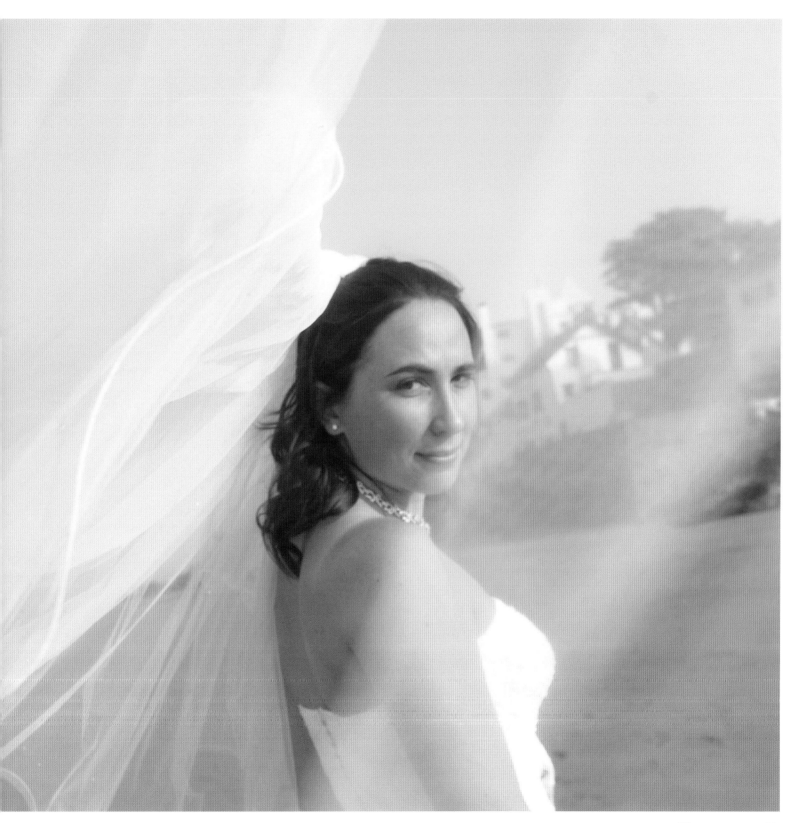

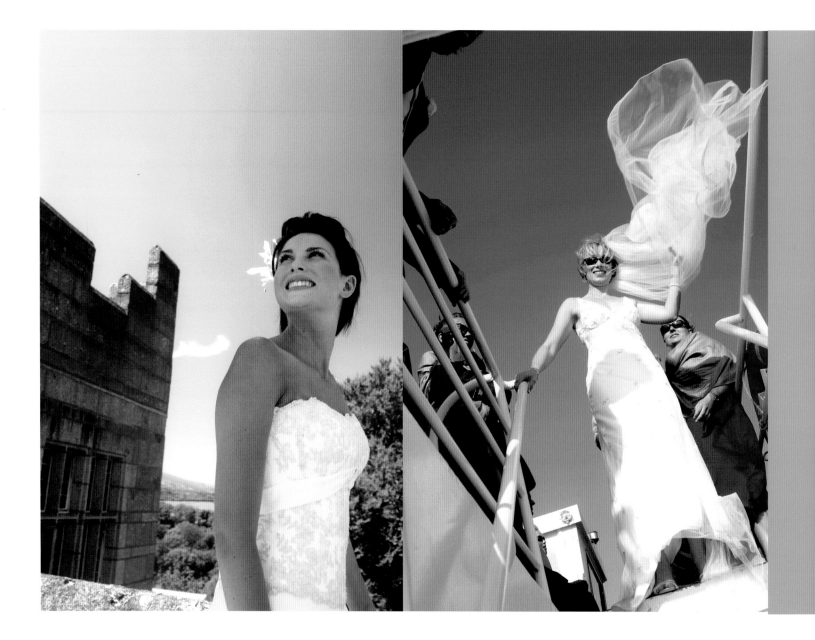

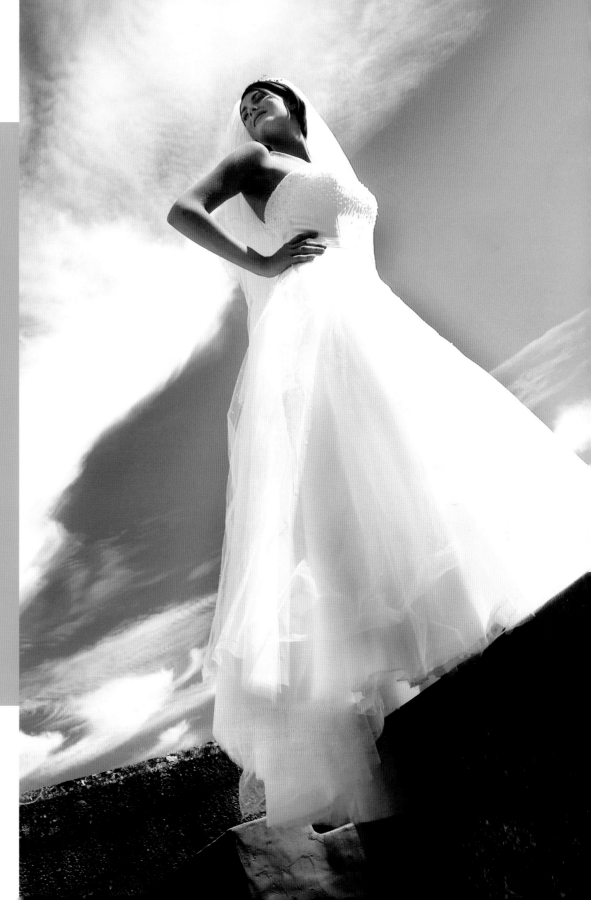

FAR LEFT *An assistant held a reflector over the bride to shade her from the sun but it was angled in such a way that the light just caught the feather on her hair, which works with the wispy cloud in the sky.*

LEFT *This lovely bride had negotiated (in her heels) the steps down on the boat. I captured the shot but the exposure was incorrent so I admitted my error and requested we redo it as I knew I was onto a winning image.*

RIGHT *A dramatic shot, taken on a rooftop, making the most of the shape of the dress and angle of her head and arm. A polarizing filter on the lens makes the clouds really stand out in the sky. Technically here it is over used, and I have lost all the detail in the blacks, but I can live with that as the clouds look amazing.*

Hens and stags

Approaching the time when the guests will be called in to be seated is a good opportunity to get some of the bigger groups such as the hens and stags. You may be working from a specific list of names for each grouping. I always prefer to know who I am dealing with in advance, but the list is often vague, so you have to be flexible.

The request for these groups to gather can get confused, leaving you with very large numbers of people and no real hope of creating anything measured and clean. As with all areas of wedding photography you will need to deal with whatever is thrown at you and go with the flow.

The champagne has been flowing and this is usually a time for everyone to let their hair down. How far you can push the boundaries depends on the crowd you are dealing with. If they are a fairly reserved bunch you don't really want them leaping about but if they are young, fun and up for it then be more adventurous for a winning shot.

If they are all good friends, the girls will need little encouragement to lean into each other and cuddle up. If you are seating them on the ground or a damp bench, have a sheet with you to protect their dresses. Place the bride in the middle and build the group out on either side, balancing shapes and sizes.

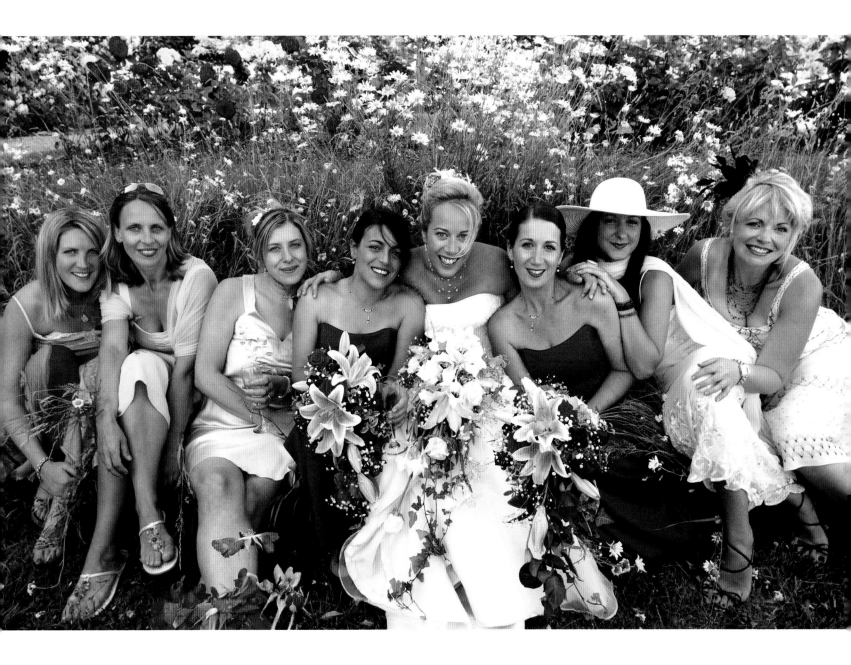

A small group of guys may play up to the camera, allowing you to get some fun, impromptu shots, but a larger group will certainly need structuring or it will get out of hand. To give some height differential and avoid a boring line-up, you can use steps or a wall or fence.

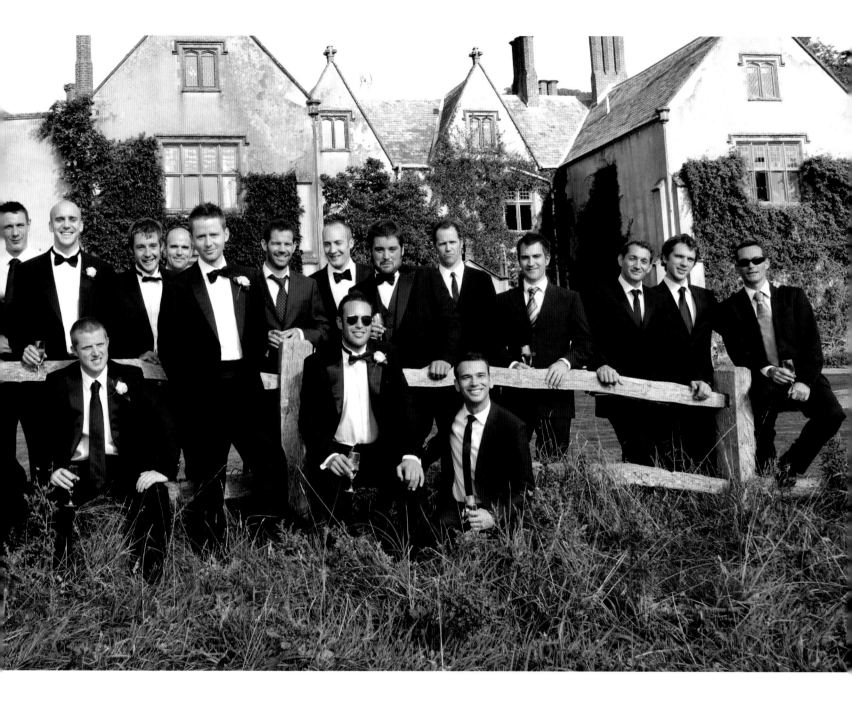

The whole wedding party

I generally only offer to do the shot of the couple with all their guests if the location lends itself to it and I can get to a good elevated position or go wide enough to spread the group out so everyone's face shows clearly. I have seen a lot of clumsy groups of people huddled together with only those in the first row really visible and it is a fairly invasive affair to introduce into the proceedings. Only attempt it if you can be sure that the end result will be worth the crowd control that will be necessary to get the finished result.

This is the one time that I become a loud, pushy and domineering wedding photographer and I will have warned the couple about the pros and cons.

Leaving this shot until last is logical as the guests will shortly need to be called in to be seated. Alternatively you could do it immediately after the ceremony if you have a clear window and a good opportunity for placing the group. This is a decision that should be made at the planning stage.

You will need to familiarize yourself with how much space a large number of people will occupy. The largest group I have photographed was 300 and I hadn't anticipated how much space I needed. I ended up climbing the drainpipe of a distant building having wildly misjudged it.

The best situation is to have a gentle slope or wide steps to place everyone on, elevating each row of people. Find yourself a high viewpoint, ideally from a second floor window. A high stepladder can also work, with someone planted at the bottom to hold you steady. It can be very disorientating having a camera in front of your face while you are perched high.

Using your key helpers at this point is invaluable, not only in spreading the word that it's time for this shot but if they can hush the crowd when needed, you may actually be able to get people to listen to your instructions. You will need to direct them if you want anything other than a jumbled mass of people and it can be tricky if you are some distance from them.

Tap a glass as if to make a speech and once you have their attention, use your loudest, most confident voice to ask them for just five minutes of their time so you can take a great shot of them all together for the couple. Put the onus on them to cooperate and you should have them on side.

Briefly explain that you can get the shot quickly and easily if you have their attention. You will always need to move a few of them around to get them into a better position. Some more boisterous crowds will be really difficult to control so tap the glass again and explain that if they don't listen it will take half an hour to get right. They are hungry at this point and will usually do as they are told. Remember to stay in control and keep it light-hearted and humorous. If you can pull it off confidently you will have the crowd eating out of your hand.

Even after all these years of shooting weddings, I still find shots like this intimidating. You are fairly worn out yourself by this stage and may feel like bawling at them. Don't. If you can do this well you may even get a round of applause and the guests will be in good humour to go into being seated.

Good depth of field is essential to make sure all the faces are in focus so use a small aperture of around f/11. A tripod will also be necessary if the shutter speed is too slow to hand hold. Using a tripod will also allow you to frame the shot while maintaining eye contact with the group you are working with.

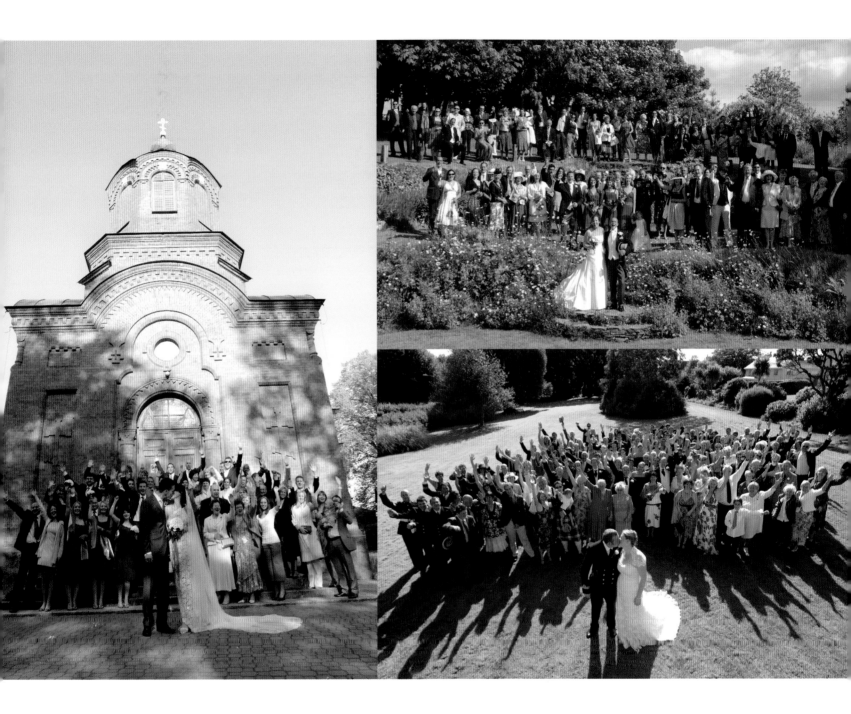

The wedding breakfast

If there are a lot of guests to be seated, you may have time to pick up some shots on your list that you haven't yet got, or you could use this time to work with the couple. By now, though, the impetus for any more stage-managed shots will have passed.

Once all the guests are seated it is traditional for the bride and groom to make their entrance and for all to stand. This can make a good shot and you will have time to set this up beforehand.

How long you stay at the wedding will depend on the package you have agreed with the couple. I always think of a wedding as three events, the ceremony, the reception and the evening party. If you are contracted to cover the entire event you won't be finished shooting until between 10pm and midnight. Cut-off points are generally after the speeches or the first dance.

The food, drink and music all adds flavour to the event and reveals the style and choices the couple made for their day. These shots may work well as a montage in the album but take care that every image stands up in its own right. Use a zoom lens to keep your distance from people and don't go around every table as you will seem to be intrusive.

Speeches

It is becoming more common now for speeches to be given before the food is served, to spare the nerves of the groom and best man. The traditional way remains the after-dinner speech, though, and by this time any available light will have gone. It can be very distracting to fire off flash throughout the speeches so I use long exposures to record all the soft, ambient light. I work with a tripod for wide shots of the whole scene and hand-hold the camera for closer shots of the speaker. In low light I use fixed focal length lenses with a very wide aperture.

Often the shots that you take in the evening will require you to push the quality boundaries. Working at a high ISO to get as much speed and wide apertures means that movement and noise will inevitably be by-products in some of the shots but this is preferable to the harsh light of on-camera flash. There are other lighting techniques that you can use, such as a light for video. That can work well in some situations but, overall, for this part of the day you should just try to capture the mood, atmosphere and fun.

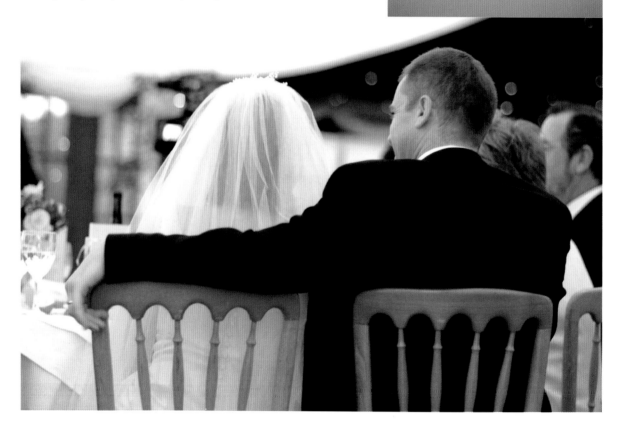

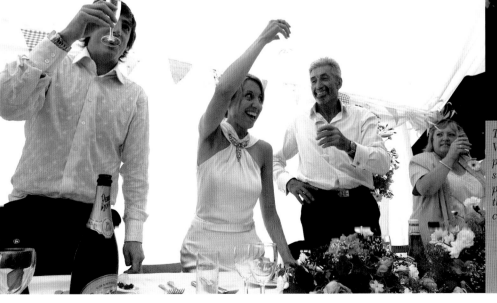

These shots are all about expression and laughter. With a long lens and a wide aperture, you can pluck people out of the crowd for some nice studies. By now you should know who the key people are so concentrate on those, watching their reactions as a joke is told or some moving comments are made.

Cake cutting

Traditionally, the cutting of the cake is an important picture for the wedding album. It is often mocked-up before the real thing as many photographers will have packed up and gone home by then.

For me, though, that is too contrived. If I am not there to capture it happening, then so be it. It is something you must agree with the couple beforehand. However, it is vital to have some shots of the cake itself as it may have been made by a close friend or relative. These days it can take many forms, from a traditional tiered construction to lots of decorated cupcakes. Cover all the angles, using a macro lens or macro setting to go in close on small details.

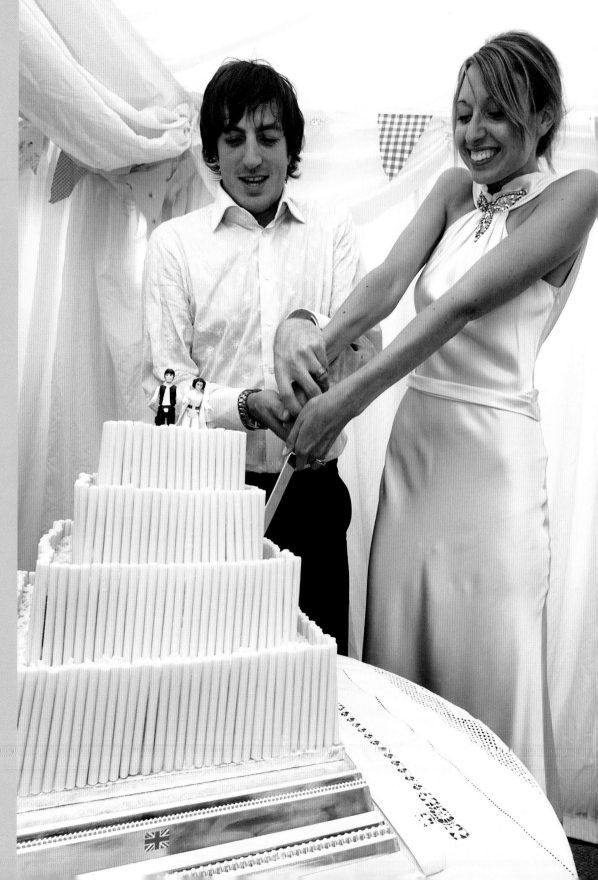

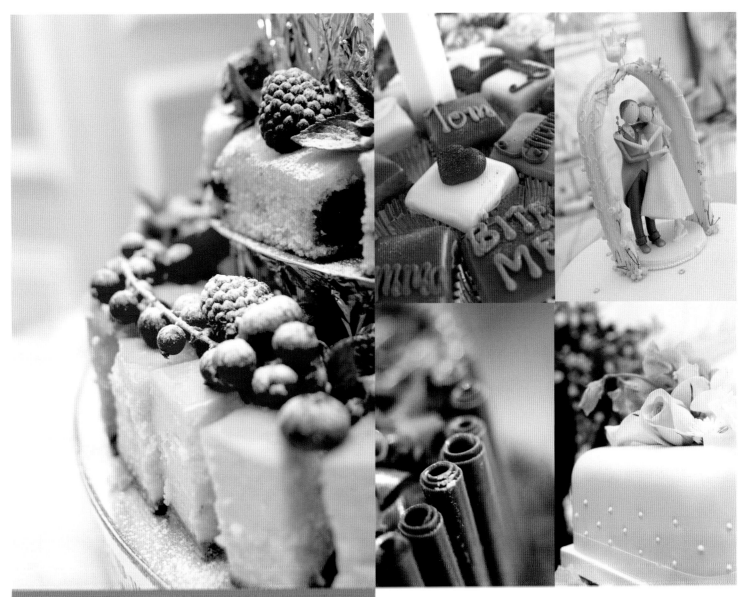

The first dance

With the speeches and cake cutting over, the party traditionally begins with
the couple taking the first dance alone. This could be a slow, romantic dance or
something altogether more lively; either way, try to capture the atmosphere and
their enjoyment of each other's company.

 The lighting will be challenging for photography. Rather than use flash, set your
camera to a high ISO of 1200 or 1400 if your can, and use a tripod. Long exposures will
record the movement and enhance the mood.

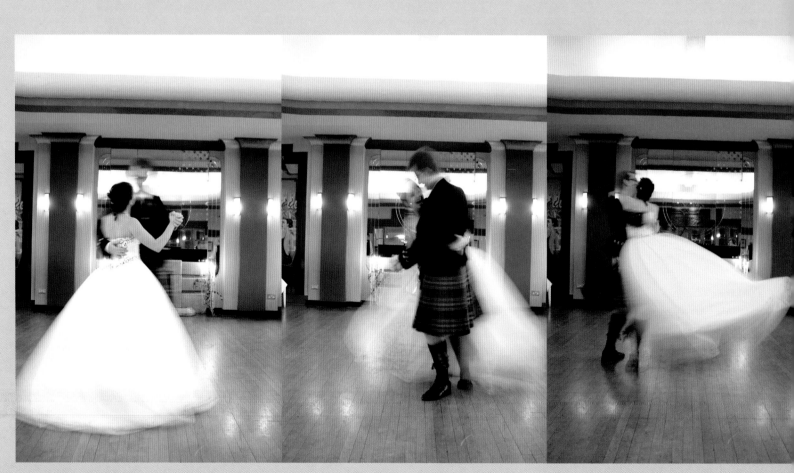

Evening candids

If your wedding photography package includes staying on into the evening party you'll have another chance to capture people enjoying themselves informally. You may also be able to stage-manage some relaxed group shots, perhaps arranging people by the bar but, bear in mind, people will generally want to let their hair down now so don't pester them.

These additional shots may not make it into the album but could be included in the digital album for friends and family to see. Remember that every hour you shoot will involve two hours in post-production so try to be selective.

The bride will sometimes throw her bouquet during the party so ask her if she plans to do this. Capture it if you can but it's a difficult shot so don't make any promises.

As with shots of the first dance, it's better to use the available light, at least most of the time, as flash kills the atmosphere. Also, people frozen in the middle of a dance move can look awkward. Blurred motion will illustrate the story rather than pinpointing every detail. If there is no strong colour content or graphic element and the background is a bit messy, consider converting images to black and white; it will also add to the reportage feel.

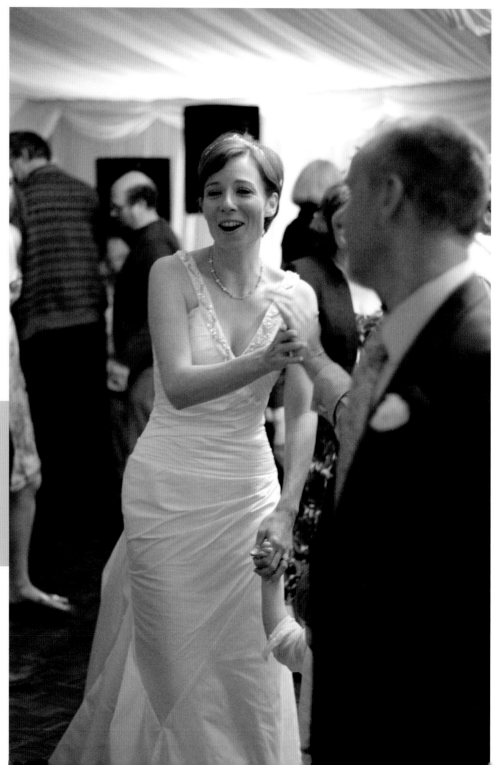

The couple leaving

I still photograph weddings where, as is traditional, the bride and groom change into going-away outfits after the wedding breakfast and leave their guests to begin their honeymoon. When that is the case you can plan a shot of them waving goodbye or driving off in a car or carriage.

These days, though, most couples will stay on to enjoy the evening celebrations, which leaves you with the task of finding another way to end the story on the final page of the album. This will obviously have to be a representation that you must look for or set up sometime during the day. You could, for example shoot them as they leave the ceremony venue for the reception or you could make sure you capture them walking away from you, hand-in-hand, during your 20 minutes alone with them. Either way, it should be an iconic image that signifies the closure of the wedding day.

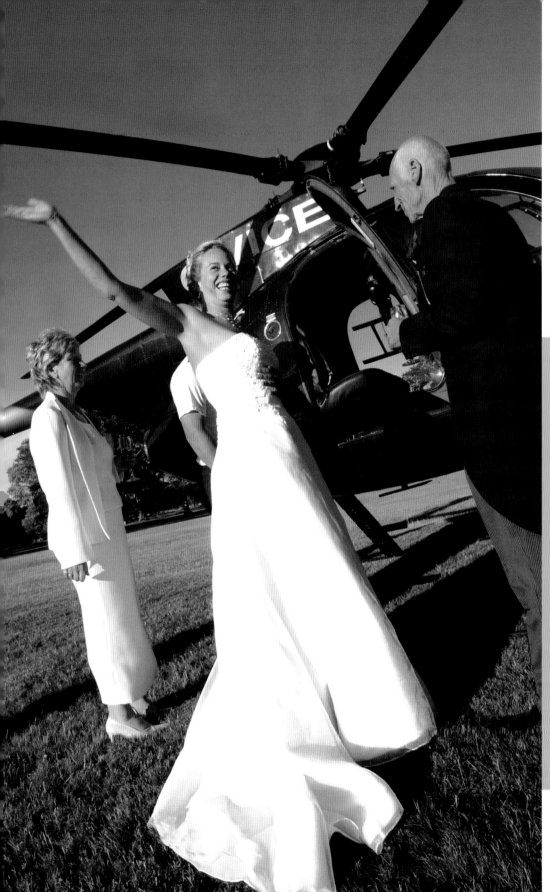

FACING PAGE *This was a traditional wedding when the couple left their guests in the afternoon. The steps gave me a good viewpoint to include the guests gathered around and it was easy to capture the throwing of the bouquet.*

CENTRE *A carriage driving the couple away works well as an end shot, even though they were actually on their way to the reception.*

LEFT *This was in the lovely early evening light and I used a wide-angle lens and camera tilt to include the helicopter in the shot.*

5. Post-Production

After the wedding

*H*aving secured the commission, undertaken all the preparations and spent a long day taking the wedding photographs you would think that the lion's share of the work would be completed. Far from it – there is still much to do.

Not so long ago, wedding photographers would, at this stage, send their bundle of films off to the lab and eagerly await the return of the prints ready to present in a preview album. We are now in the digital age and most of us will have a folder on the computer full of image files. After a stringent back up and catalogue procedure, the edit process begins: each image must be opened, considered, kept or discarded.

Once you have your final edit, you must then process all the files. No matter how well you have executed your exposures, you will invariably need to adjust white balance, colour and contrast and make your selections in black and white. You then need to sequence, re-number and convert your files ready to present to the client.

There are many ways to present the images. I offer a secure client area on my e-commerce website, a slideshow DVD and a printed contact spiral-bound proof book. Once they have made their selection, the next stage of the job begins which is to produce the finished collection. This usually includes a wedding album for the couple and sometimes for the parents, a selection of prints for family and friends and possibly a few framed or mounted pieces.

This will, of course, depend entirely on what level of service or type of package you are offering, but as you become more experienced and look to maximize sales, you will want to include a range of products to offer your clients.

Backing up the files

First things first. The wedding is over and you will be eager to see your shots and no doubt nervous that you have captured everything successfully.

I have a protocol in place when I download, to ensure everything is safe and secure. Just as you have your paper job file well ordered, your virtual filing system also needs to be highly organized.

I always have a main client folder, which I title with the surnames of the bride and groom and their wedding date (e.g. Roberts-Davies 05.06.10). Within this folder sit sub folders, the first one being a 'masters' folder where all the original image files are kept. This stays intact. Your subsequent folders will hold the finished edited and processed files. It's important to keep the original master set should you need to revisit them at a later stage.

Making copies

Once you have your 'master' folder, burn a disc, copy the images on to an external hard drive or use whatever other method you choose, but back up, and do it before you do anything else. Then double check your back up; is it complete and working? I am never complacent about the importance of this. I have a server with a dual drive and an external drive that goes off-site as well as a disc in the job file. This is the first of other back up procedures that follow. Many hours will go into producing the final edit ready for presentation and you will definitely want to back up again at that stage.

So now you can breathe easily, the wedding pictures are safe and sound. You may need to go off to shoot another job and the critical moment comes to reformat your memory cards. After all these years, I am still reluctant, hesitant and nervous to wipe the wedding and reformat the cards!

Using film

If you are working with film, you should take the same care and diligence to get the films to the lab. Deliver them by hand or secure courier. If you use the post, choose a service that gives you a tracking number. Make sure the lab has the same approach when returning images.

The edit

*I*f you are not doing so already, you should certainly be shooting in RAW format. RAW is basically an uncompressed file. It's much larger than a JPEG so will take up much more space on your memory card and, in turn, on your computer, but it allows you to maintain the quality. This is because you will do the vast majority of the degenerating processing, such as white balance, exposure, colour balance, greyscale and cropping, on the RAW file before converting to a user-friendly JPEG. Your finished JPEG will be saved at the highest possible resolution and the quality of the image will be maintained.

As RAW files are large and memory hungry, you will need powerful software and a fast processor to cope. Thankfully, most modern machines can chew through the workload but in the early days of digital we would be forever waiting for the next file to load, creating a frustrating bottleneck in the process.

Software

Industry standard software for processing RAW files includes Nikon's Capture, Adobe's Lightroom and Apple's Aperture. I use Lightroom and it has transformed the way I work. I import the RAW files into Lightroom and am able to assess each image full screen very quickly and make a first edit selection, which will be refined again for the final edit. While you always aim to offer your client a great selection, you don't need to show them everything, only the best and most relevant.

Selecting

As you become more experienced at editing, you will get faster and more ruthless. You may have agonized and really struggled to get a certain shot that just doesn't work, so bin it and move on. You will still have it in the master folder should you want to retrieve it. Inevitably you will have to keep some shots that perhaps aren't that strong, for their content only, but ideally these will be few and far between.

When shooting during the wedding, you will no doubt be tweaking each shot as you go, aiming for the best angle, lighting or expression. By the end of that process you will have a run of similar images in a 'set', with small but important differences – hopefully with the shot perfected among them. When editing work set by set, keeping the best: working through the wedding slowly and methodically from start to finish. Resist the temptation to fiddle about with favourites or you will get distracted from the task in hand.

Numbering

Once you have your final edit, you need to check that everything is in sequence and re-number your files. It is much more manageable for the client to deal with and looks cleaner overall if you provide the shots in a numbered sequence.

Re-sequencing is only an issue if there are two cameras working on the day. As long as the time and date settings on both cameras are correct, Lightroom will order these for you. A little manual shuffling may be necessary if you separate and cover different subjects at the same time.

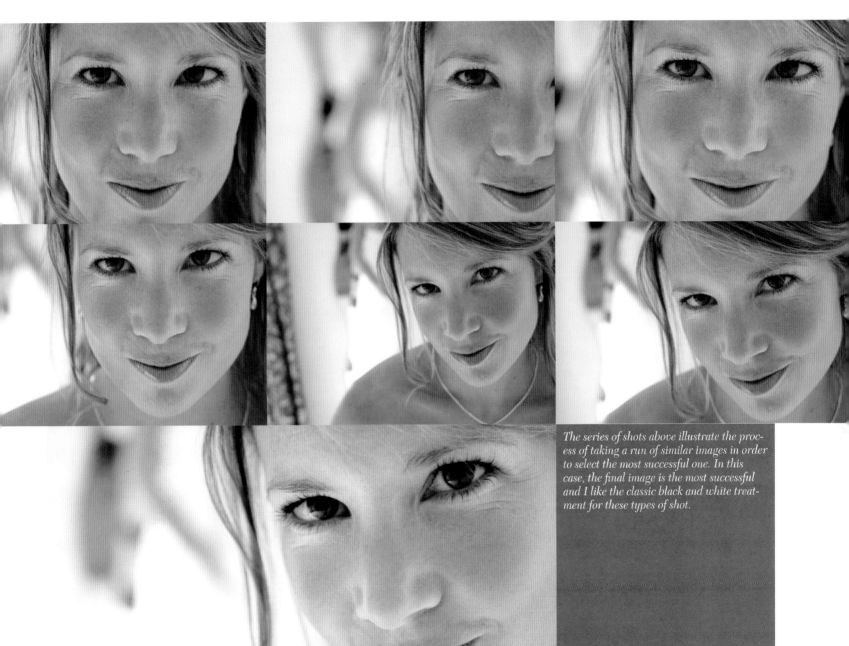

The series of shots above illustrate the process of taking a run of similar images in order to select the most successful one. In this case, the final image is the most successful and I like the classic black and white treatment for these types of shot.

Processing

When you have your final edit, numbered in sequence, you can start to process the selected files. Many people are unaware that this routine still has to take place with digital, but it's no different to film where the lab would always have to tweak the image to bring it into the correct range.

No one should provide the client with unprocessed files. They will all need to be brought into a similar range of balance, exposure, contrast and colour parameters. Bear in mind that you will have been shooting in radically different lighting situations, having to make a huge variety of exposures. Hopefully most will be correct but you won't be able to get it 100 per cent right every time. Ultimately you want your final collection to look consistent, clean and well-exposed.

Adjusting the RAW files

At this stage, there is always the dilemma about how much to 'process'. Remember that this is the client's first viewing of the images as proofs on paper and, perhaps, online. You won't want to spend too much time on individual images that may never be included in their finished collection. Equally you want everything to look as good as possible overall and to boost your sales; it's finding the right balance. I do an overall clean-up, convert, say, 30 per cent into black and white and take a few favourite, winning shots through to the final perfecting stage to give the client an idea about the full potential for each image.

Just as for the edit, working set by set, adjust your white balance on the first image in the set and duplicate the settings, making sure it is consistent across the remaining set. Adjust your exposure, lighter or darker, and tweak the contrast. As you are working your way through, convert some to black and white – the settings will be different from those in colour.

The crop tool in Lightroom is brilliantly intuitive. I am 'old school' and still like to frame my shots in camera, although I have to admit that I am using the crop tool more creatively now that it is so useable. But most of the images in this book are as shot.

Up to this point, work on the images will have been completed exclusively in Lightroom. I only bring certain images into Photoshop if absolutely necessary. Photoshop will come into its own before I produce the prints, when its more refined tools are required for retouching and final processing. I like my images to remain fairly pure and unadulterated, keeping Photoshop trickery to a minimum. Also, when you are offering up hundreds of images, it's not realistic to spend hours retouching everything frame by frame. The more weddings you do, the more you have to streamline your workflow, otherwise you will be spending a lot of unpaid and tedious hours in front of your computer.

It is certainly worth including a few hand-coloured images and other effects among those you show the client, though. I always highlight these as 'suggestions' in my covering letter, should the client miss the more subtle effects and be confused as to why one image may look quite different from the rest.

Converting to JPEG

Once you are happy, it's time to export and convert your RAW files to JPEG. I always export a set of low-resolution files at 72dpi, perfect for viewing on screen, either via the web or to use for the client's slideshow. The high-res JPEGs are used to print the proofs. In your virtual folder you will now have sub folders, holding 'masters', 'final edit', 'low-res JPEGs' and, if you are using Lightroom, a Lightroom catalogue.

I choose to keep control of my workflow. As my company has expanded, it makes sense, but other options are out there. If you feel you don't have the time or the skills involved then you could choose to outsource the post-production. There are numerous agencies and individuals doing this type of work.

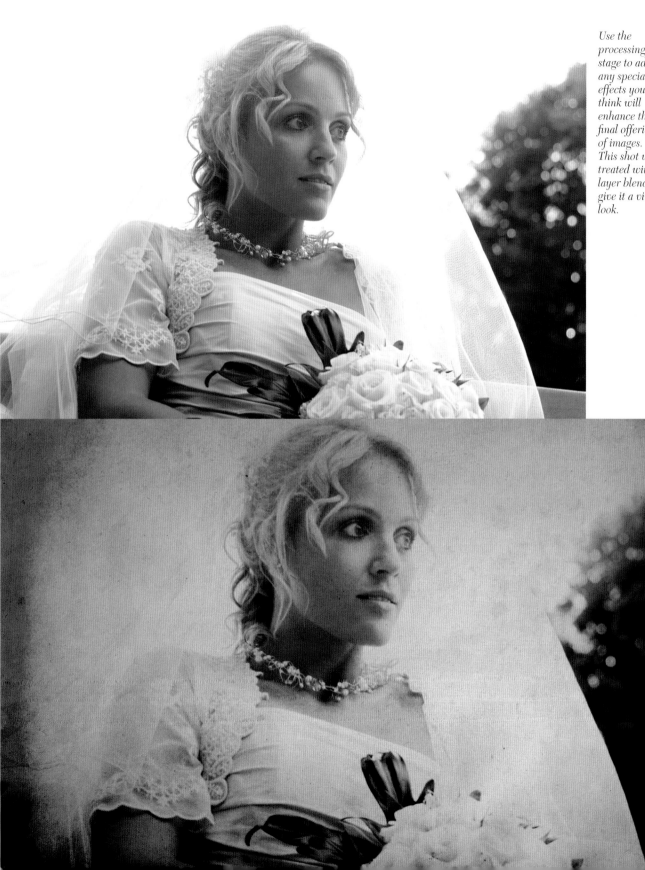

Use the processing stage to add any special effects you think will enhance the final offering of images. This shot was treated with a layer blend to give it a vintage look.

6. The Finished Collection
Presenting to the clients and securing their order

You will have already agreed with the clients how and when you are going to have the images ready for them to see. Make sure you deliver on time, generally allowing two to four weeks. I am usually able to have everything ready within two weeks but if you have other work commitments it's worth giving yourself a little breathing space. With so much to do in the post-production of the images, you don't want to rush the process.

On occasion, I have been asked by the couple to provide a same day turnaround. That is demanding, as I choose to deliver everything with a final polish that requires time, but 'what the clients wants, the client gets', is my philosophy. As long as it doesn't compromise the standards, it is possible, you just have to set yourself up beforehand with all the necessary equipment and charge accordingly.

I generally send an email with a direct link to their images on my website and post off the proofs with a covering letter indicating the next stage of the procedure. Family and friends will also be eager to see the images but I always make sure the couple see them first, unless we have agreed otherwise.

Presenting your work can be a tense time for the photographer. I always contact the clients to make sure they are happy with the results, though some couples, very sweetly, will give you instant positive feedback without you having to call.

Occasionally you may come across a situation where one or both of the couple have a completely preconceived idea about what the shots are going to look like. Perhaps they noticed you taking a certain shot and subconsciously registered that frame in their mind. Imagination is a complicated thing and they may be surprised and possibly thrown that the image you actually recorded doesn't match their expectations. In such a situation, I find there is a settling in period. Once they have lived with the images for a while, their perception shifts and they start to recognize that they are a great set of photographs and that you have done your job well.

The final selection
The next stage is to arrange another meeting with the couple. They will need to make their selections for their 'finished collection' album, prints and frames. Your package could include an album with a set number of prints or you may decide to simply hand over a disk of all the images at high resolution for the client to take care of the prints themselves. I would be concerned that the client could be disappointed with the end results and I consider it part of my overall service to ensure that the couple walk away with the finished collection. I know how I want my images to look when they are finally printed and presented and, as a professional photographer, I consider this aspect of the job to be part of the whole skill set. Certainly at the high end of the market, clients expect this service and want to be offered choice.

Receiving the order
Try to turn the job around within a reasonable time frame. You should look to have finalized an order a couple of months after the wedding, which will give you a six-week lead time to fulfil and deliver.

Usually the couple are really eager to receive their finished collection but sometimes it can be difficult to motivate them to make decisions and place an order. Some people can deliberate endlessly, making the whole process a fairly daunting task for them. Or, life takes over and it's one of those non-urgent things that keeps getting postponed. Added to this they may be feeling 'hard-up' after the wedding and honeymoon.

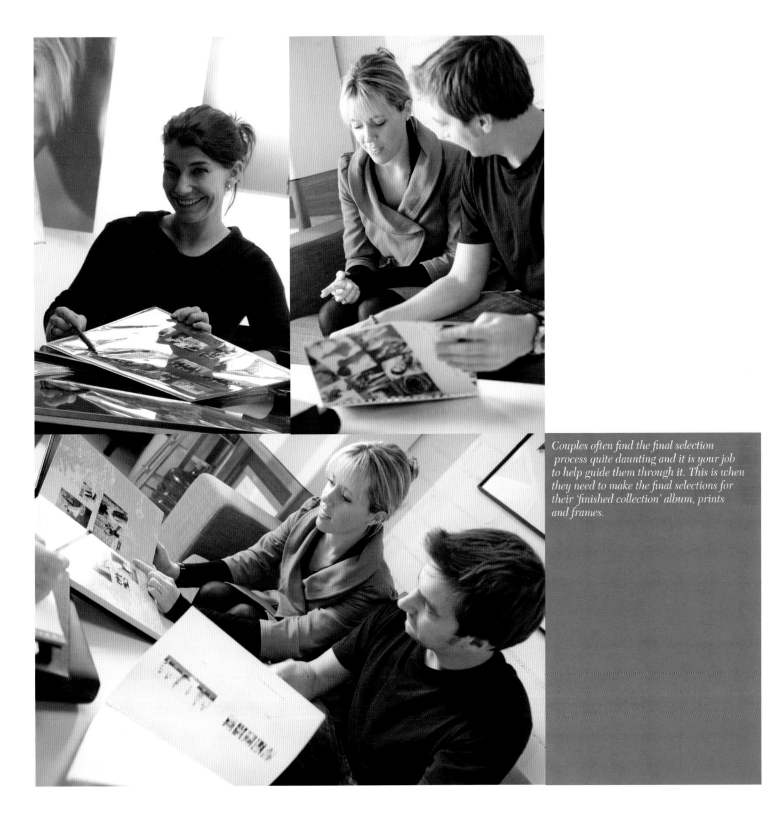

Couples often find the final selection process quite daunting and it is your job to help guide them through it. This is when they need to make the final selections for their 'finished collection' album, prints and frames.

Nevertheless, you must close the job and move on. Throughout this final stage, I try to help as much as possible. For example, when we send out the proofs I tick the ones I like and give them a list of products and prices so they can think about what they can afford. Then I put a request in for a meeting and set some timelines. It's important that they will attend this prepared, having made at least an initial selection and with some idea of what they want, otherwise you will have a very long session with them.

Meeting the couple

I always enjoy seeing my couples again and it's nice to look through the images with them and get their feedback. The same rules apply as for your initial consultation: present yourself professionally and make sure you are clear about what you are offering them and that you have samples to show. They may not want to firm up an order with you at this stage so have price guides available for them to take away.

With your business hat on, you should see this meeting as an opportunity to maximize sales. Even if you are charging 'top dollar', the amount of hours you have spent working on the wedding have stacked up by now and you should look to make a healthy and honest profit. This is potentially a valuable meeting that could make all the difference to the net worth of the entire commission.

At the start of the meeting, I run a slideshow presentation of all the images, rolling through fairly quickly as they have already seen them. I chat to them throughout to get an idea of their requirements. We then establish what is on their wish list and I show them a few products that I think would fit.

Having determined their likes and dislikes you should now have a fairly clear idea about how to proceed and secure an order. I suggest you tackle each requirement they have in turn, as they will easily get distracted. For example, when they are considering their favourite shot for the album page, they will start to think about it for their mothers' orders and it can slip into confusion. It's up to you to lead the meeting and help them through the selection process.

Start with the most complicated product, which is usually the wedding album. Establish roughly how many shots they have already selected for the finished book. From this you can give them an idea of how

RIGHT *Use a dedicated order form to write down all the information clearly, double checking everything for accuracy.*
LEFT *Clients may like the idea of close up images but have second thoughts when they see themselves portrayed this way.*

many pages they are going to need and the likely cost, given the choice of album and finish they are considering. Give them feedback on their selection. They will often miss crucial shots that will really work in bringing the album design together.

Some of my photography is 'brave'. By that I mean I will often crop radically into a person's face in a close up portrait, or come at a subject from a very low, wide angle. The couple will have chosen me because they liked these type of shots in my portfolio, but when they see themselves in this light, it is surprising how some customers will play it safe and fall back on the less adventurous images. It can be frustrating but it's their album, and it's your job to make sure they are going to love living with it in the future. I may try and persuade, but never to the point where they will regret it every time they look at their album.

Once you have established the album order you can look at any other requirements they may have. Some couples will want to sort out their family orders and may come prepared with a list. Often it's just a handful of reference numbers with no preferences for size or for colour or black and white. You may have to make suggestions and confirm with a few phone calls.

Always suggest a few of the best images you think will lend themselves to a statement piece for their home. They may not have considered all the options you have available and you could increase your sales.

By the close of the meeting you will, hopefully, have secured your album order or upgraded your existing album package and taken additional orders for the family, friends and extras for the couple. If you have an e-commerce website, you may pick up further orders from this.

The order form
There will be lots of information for you to assimilate and process. Consider this: say your client selects 120 images for the main album, 70 for the parents' album, 20 images for loose prints for family and friends, three small prints for frames, one large mounted framed statement piece and three for canvas stretch. Particular favourite images in the album will also be repeated for the other items on the order but will need to be cropped differently or converted to black and white. You can see how one image can be reproduced in numerous different ways and it can be a logistical

nightmare to ensure that you get it all output correctly to avoid expensive mistakes.

My advice is to have a dedicated order form and write down everything very clearly. I will often make lots of notes during the meeting and then allocate half an hour as soon as the couple have left to write up the order clearly, product by product, double checking everything. It's all very time consuming but essential.

Your order form should include image numbers, colour or black and white, size, print type (standard /non standard), full frame or cropped and product information. File copies of this for your records and send your customer a confirmation of their order, giving details of the type of album, cover spec, page and mount colour, print choices and sizes. This may save costly work being produced if there has been a misunderstanding.

Make sure that by the close of the meeting your clients leave clear in their minds about what they have ordered, how much they have to pay and when and how they can expect to hear from you again. If they haven't been able to finalize their order, be clear about the information they need to supply to you, or for it all to be tied up within a reasonable time frame.

With the order established, the process of designing, printing and assembly begins. If you are outsourcing some or all of it, you will need to place orders and oversee production with your suppliers.

Signing off the job
I don't let anything out to clients unless it passes my quality control 100 per cent. It's very rare that everything in the order is perfect first time; prints will sometimes have to be re-run or mounts and frames may get marked. You must decide when the wedding will be archived or disposed of. I keep the job live on my system for one year from the wedding and then it is archived to keep my systems running efficiently.

I often retrieve or add to the archive as clients will request additional prints for anniversaries or other occasions. One of the most rewarding aspects of the job is to build an ongoing and happy working relationship with clients. As they go on to have children, they will return to you again and again as their family grows.

Developing your product range

It has taken me some time to build on my range and it's constantly evolving as suppliers introduce new products and trends change. It's vital that you keep in touch with this to stay competitive and fresh.

I like to keep things simple and elegant with the emphasis on quality, as I firmly believe that the images should be strong enough to stand on their own. I see a lot of rather mediocre work hiding behind elaborate page layouts and extravagant albums.

When it comes to sourcing the albums you want to use, there are a number of important considerations you need to make before committing to promote a product. The simplest option is to buy your album and range of mounts, produce your prints to match the size of the mounts and paste and stick the whole thing together. I still do this on a few gift range albums.

A more sophisticated way is to use the design software that the company or lab supply with the albums to design the page layouts, then print and assemble. Again, you could choose to outsource all or part of this process. The important thing here is, literally, don't judge a book by its cover. I have used some beautiful looking books but the design software was a pig to use.

Within my album range I have a favourite manufacturer. The design software that accompanies it is straightforward and well developed, my team are familiar with it and it does what I want it to do. I can produce proofs of the page layouts to submit to the client for their approval and sign off. Amendments are sometimes made, but usually we are trusted to get on with the job and bring out the best in their selection.

labs) now offer their own range of albums and wall products, including a design and assembly service – a one-stop shop.

Once the client has approved the design layout, I output to print and order in the album and the mounts. When I have all these components together, I assemble. I prefer to keep this process in-house to maintain total control over every aspect.

I choose to outsource the production of other products within my range, if they can match quality and compete on cost. For example, for years I printed and stretched my own canvas. I could never find a company that delivered on style and quality, so I took on the task of bringing it in-house. It involved sourcing the canvas and stretchers, defining the sizes I wanted to produce them at, and having the tools for assembly. I needed them to be properly heat sealed for protection, which involved sending out to a specialist company. It was long-winded and costly, making my product better but much more expensive than those elsewhere. Luckily I have now found a really good supplier that can match my product. It costs less and is more time effective so I have been able to pass on the saving to my customers, offering better value.

Sourcing products

The best way to research new products and find good suppliers is to visit a photographers' trade fair at the biggest and best exhibition centre. Most of the key players should be there so find the companies that you like the look of and talk to them. They are there to sell and no matter how small your operation may be, they should still give you time to assimilate what they are offering. A lot of professional print houses (photo

If you choose to produce your own albums rather than outsourcing the work it is important to invest time and energy into deciding what is the best system for you. Properly researching the products, suppliers and software systems available will save you time and money in the long term.

What to charge?

This is the same tricky question that you will have had to answer when you came up with your rates to cover the wedding. Most photographers, unless they simply hand over a disc, include an album or a 'spend' to the value of an album. This can work well if the couple upgrade their package as a simple adjustment can be made for the final bill. However, it's more difficult to decide how much to charge for the upgrade and extras like more pages in the album or additional prints and products.

For example, in their album upgrade they will need an extra six pages (12 sides). They may have chosen one large image on one page, six images on another page and so on. If you start to break down the cost per image/per page it can get incredibly confusing for the client and will stall the flow of the sale if you have too much to explain. Also, it becomes so time-consuming for you to administer that it negates making the charge in the first place. Keep the structure simple and accept that you will make more on some items and less on others but it will be fair and balance out overall. Look at how other people are structuring their charges and find a way that suits you.

I still struggle with pricing; there is no easy formula in this business. How do you quantify the time you spend on perfecting an image on the screen for output to a 6 x 4in print as opposed to the same amount of work for a one-size canvas? The time you spend on the image will be the same, the only difference being the material costs. To add to the confusion, some images will require more time than others to produce an optimum print, but the price will remain the same.

Breaking down your costs

Look at each product you are offering and break down the costs: the paper and ink, the albums, the mounts, the glue and everything you need to put that job together including the staples! Don't forget to include the tax, carriage and labour. Do a time and motion study on how long you are taking to process the images and put a price on that. Bear in mind that I process initially for the viewing and then again for final output. This is a more difficult equation so a ball park figure is the best you can aim for, given the nature of how each aspect of the job can vary.

Your price will depend on the materials and products you are using and the level of finish you are providing. If you're aiming at the high end, you will incur high material costs and at the entry level you will have to offer more inexpensive options. You have to ensure that your customers understand the difference between, say, an image printed on a fine-art paper, in-house with you standing over it, to a standard machine print being run off at the lab.

Ultimately, you will come up with a figure, which you can compare with your competitor's rates. It's a laborious but unavoidable process. When you analyse your time and costs as well as your suppliers' rates, it forces you to really understand the business.

My strategy is to give the customer a base price for a standard-level service with the option to charge more should I need to spend longer on a particular job. This works for me, but I am offering a bespoke, high-end service.

You should look to up-sell and increase your sales post wedding. How much you can do this will depend on the original wedding package you offered.

7. The Wedding Photographer's Toolkit and Techniques

Down to basics

In my opinion, there is no definitive best camera, best lens or best bag. There are a few industry standard items that no self-respecting photographer would be seen without but, for me, it's not about the gear. I just don't get that excited about the hardware and, even less, the software. These are simply tools to help me achieve great images, but I appreciate I'm in the minority here.

At the risk of entering dangerous territory, I think it's fair to say that there is a huge male/female divide in the industry. A lot of the gear and the photographic press is designed and marketed to appeal to men. I know a lot of women photographers doing a great job who are not truly represented by the industry. Maybe it's because the boys are more into the gadgets and 'techy' talk, but I think the industry is missing out on the girl pound and could look at this more from the female mindset.

I run a series of workshops and often clients turn up eager to show me their bag full of gear, yet when they show me their work they have been unable to produce the simplest well-structured shot. For them, the love of photography is about the beautifully engineered equipment and the mind boggling capability of digital technology. There is nothing wrong with that, but don't think you can't enter into the world of serious photography if you haven't got the latest, most expensive gear.

It was simpler in the days of film, when image quality was much less of an issue. The SLR camera body was merely a receptacle to hold the film and the difference between good and exceptional quality was defined by the lens, film and processing. I started out with a very basic Nikon body with a few really good lenses and a second-hand Bronica kit with a Metz flash. Moving over to digital in the very early days was costly and quality was an issue.

These days there is much greater disparity in quality and performance between an entry-level digital SLR and a top-of-the-range professional camera body. There are so many makes and models in the marketplace it can be very confusing and no sooner have you done your research on one type than it's superseded by something better.

Debating Nikon versus Canon and Mac versus PC can be left to the many consumer magazines and forums out there. I am a Nikon and Mac girl but you can make just as good images using anything else, it's just a case of finding what works for you and making sure the gear has enough power to deliver what you are demanding of it.

For the most basic kit you will need a film or digital SLR camera body with a back up spare, a few good quality lenses, some essential accessories such as flash, SD cards (8GB at least), spare batteries and chargers, and computer hardware and software. I am always adding, replacing and improving. I am not precious when handling the gear; I don't have the time. I work the gear hard and replace and upgrade as necessary, keeping what's a bit old and tired for back up.

As you raise your game you will place more demand on your gear because you will need all the benefits that high-end equipment can provide. However, remember that achieving great images is not all about having the most advanced kit.

Which camera?

The first thing to consider when shopping around for your camera body is your budget: some of the top professional cameras require a small mortgage. The more expensive the camera, the more features, tougher body, weather sealing, higher frames per second rates and bigger buffers to process files super quickly it is likely to have. However, when you're starting out, many of the 'prosumer' cameras – those aimed at the pro/amateur market – can handle most demands, just not with quite as much speed or fine-tuning.

The sensor

Secondly, you need to consider the sensor size and its crop factor. On some camera models it is smaller than a standard 35mm frame and this will affect the focal length of your lenses, making it an important consideration. For example, I used the Nikon D1X and then progressed to the D2X. Both of these models increased the focal length on my lenses by 1.5mm, so my fixed prime 80mm lens behaved like a 105mm.

I am currently using the Nikon D3 as I particularly like its capabilities in low light. It can achieve great exposures at a high ISO setting without too much digital noise. It's designed for sports and action photographers and for that reason I find it works really well at weddings, when you have to contend with so many different and often poor lighting environments quickly. However, it has a full-frame sensor so the lenses 'do what they say on the box'. Now my 14mm is a true wide-angle and my 80–200mm is no longer long enough, so I have had to buy another lens. Like everything else in this business, you have to evolve and reinvent yourself all the time.

Megapixels

You also need to consider the megapixel debate. A megapixel simply means one million pixels and a pixel is a single dot in a graphic image. Your computer screen and your digital images are made up of millions of pixels. If your camera is 12 megapixels (12MP), it means that any pictures it takes (on its highest quality setting) will consist of 12 million pixels.

Most of the time you will be producing prints up to A3 size (297 x 420mm) for albums, occasionally going bigger for the wall products. Now, even most prosumer cameras are at least 12MP and that is increasing all the time, which is more than adequate for that reproduction and if you have a well-executed shot you can comfortably produce much larger images.

For the commercial market shooting for billboard hoarding, you may need more pixels, but are you going to be doing that? Some of my favourite and best shots ever were taken on my now obsolete Nikon D1 as JPEGs. True, they may not withstand huge enlargement and may have less detail than I would prefer, but the shot is still good. Really these issues are now much less of a problem.

Because one camera has a certain amount of megapixels doesn't mean that it will take better pictures than one with a lower amount. There are many factors that can affect this, including the build quality. So don't just jump in and buy a lower priced 20MP over a higher priced 12MP model, for example.

All the leading brands make solid, reliable cameras. All will have variations in the colour rendition, different noise patterns and different lens options. Do your research, read the reviews and find a camera that you feel comfortable with at a price you can afford.

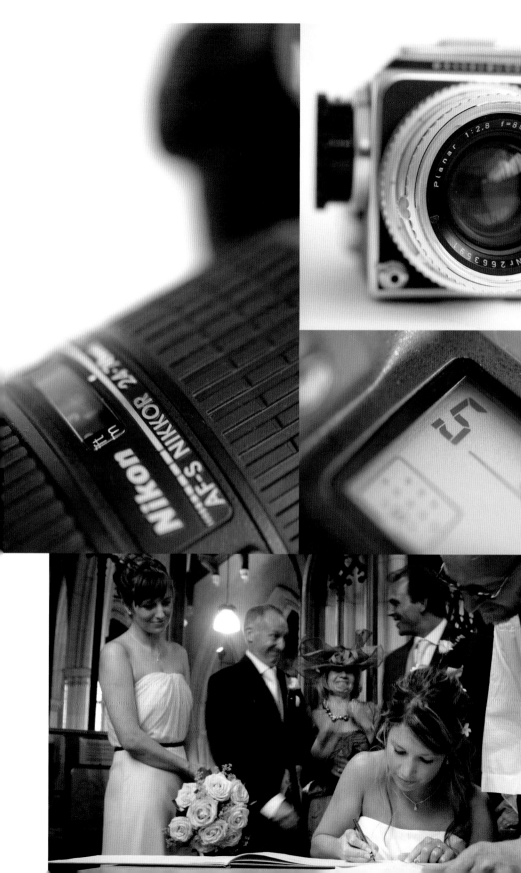

LEFT *This shot was taken in very low light, however, the Nikon D3 handled it so well that the image has very little 'noise'.*

Lenses and accessories

Having found your camera body, you will face the choice of a vast array of lenses. My advice is to go for the best you can afford. There is not much point in having a fantastic camera body if you then stick poor quality optics in front of it.

Should you go for prime lenses or zooms? Prime lenses are fixed at one particular focal length whereas zooms have an extensive range of focal lengths in one lens. I would say you need a mixture of both, as each has certain advantages over the other. I keep a 24–70mm f/2.8 zoom lens on my camera most of the time as I find it a great workhorse.

I use one other longer zoom and a few prime lenses, notably a 14mm wide-angle and an 85mm, which I love for portraits. It has got me out of some very tricky low-light situations as it is a fast lens with a very wide f/1.8 maximum aperture, which allows more light to reach the sensor. My macro lens is another favourite, indispensable for really tight, full-frame detail shots.

As cameras become more capable of maintaining high quality at a high ISO setting, working in low light may not be a good enough reason for you to pay a premium for a fast lens. However, they have another advantage in enabling you to use a very shallow depth of field to focus on a particular subject, throwing the rest of the frame into soft focus (see Depth of field page 151).

Zoom ranges
There are zooms available that cover a huge range from extreme wide-angle right through to telephoto. Generally, the greater the range, the more compromises are made in terms of quality, unless you spend a great

deal of money. Zooms lenses have lots of elements, all of which scatter light internally, reducing the sharpness and contrast of your picture. Zooms also tend to be slower (needing a longer exposure) with all the negative issues that entails.

If you're happy to change lenses during a shoot and can bear the extra weight in your bag, choose a short-range zoom, such as a 24–70mm and a longer prime lens that will deliver on quality. If convenience is important to you, there are some very well made 70–200mm lenses on the market but expect to pay a hefty sum for them.

Take care when removing and fitting lenses as dust can be attracted to the sensor and cause problems, especially on digital SLRs without dust cleaning features. Always remove and replace lenses quickly with the camera switched off and facing downwards. With practice, it becomes second nature.

When you buy a lens make sure it's compatible with your camera body; Nikon and Canon have totally different fittings, for example. Some lenses are designed for smaller sensors and older lenses may not work on newer bodies.

Lighting equipment
You will need a dedicated flashgun, preferably two. Lots of prosumer cameras have a built-in, pop-up flash, but you will need one that gives you more control over exposure and direction. As with lenses, make sure it's compatible with your camera body.

I use flash only when I absolutely have to and in the most subtle way possible, to fill shadows or gently boost the light. I prefer to use the available light whenever I can, increasing my ISO, using a fast prime lens and maybe a tripod, and setting a longer shutter speed to achieve the best exposure in low light.

There will be circumstances when any one of those techniques will not be suitable, or there will simply be too little ambient light to make an exposure, and

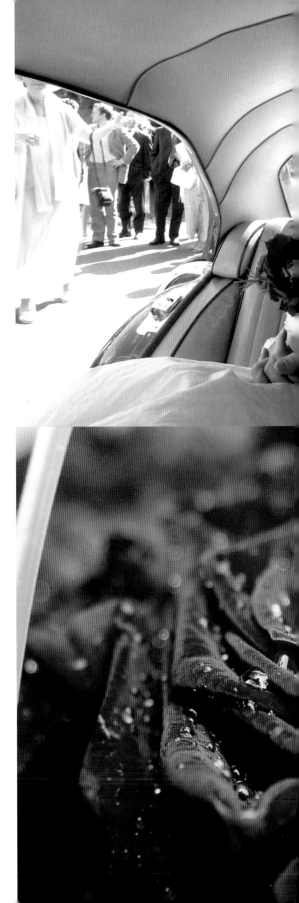

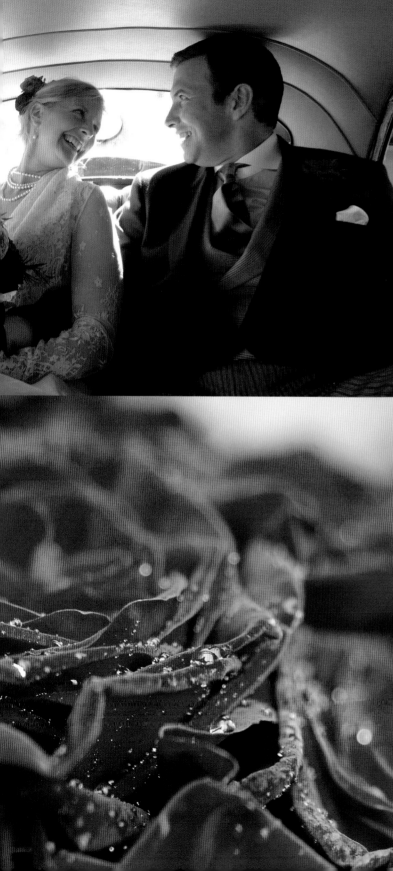

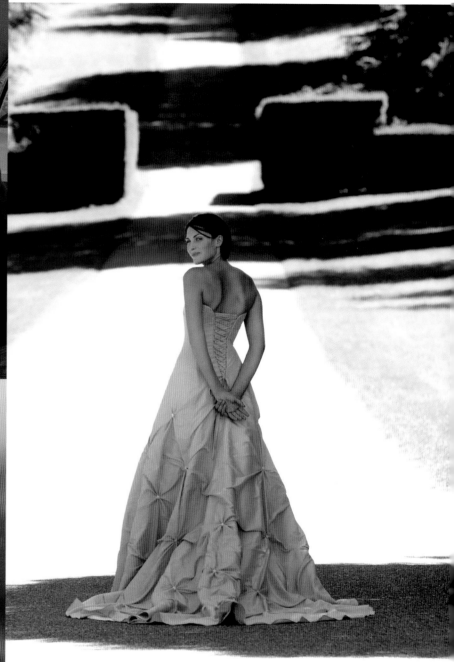

ABOVE *This shot was taken with a long lens which has foreshortened the perspective for extra drama.*

LEFT *I often clamber into the car with my wide lens to capture the overall scene within the confines of the car.*

BOTTOM LEFT *A macro lens is indispensible for close up detail shots such as favours, gifts and flowers.*

you must resort to using your flash as the main light source. However, direct flash is harsh and can kill the atmosphere. Ideally, there will be a pale ceiling, or at the very least a wall, where you can angle your flash to bounce back and illuminate the scene. If not, you can add a hood to spread and soften the light.

Sometimes you may want to use more than one flash head to light some of the background scene as well as your main subject. The flash on the camera automatically fires the second flash, mounted elsewhere. Not all flash heads are capable of this but simple accessories are available to make them synchronize with each other.

There are a few, rare exceptions when I would consider bringing in a continuous light source to light a specific area, for example when there are lots of group shots to do at a winter wedding, with nowhere to bounce flash or very low ambient lighting. Otherwise it's too intrusive and cumbersome for my way of working. I know of other photographers who swear by it, though, and there are some very good options on lights, with interchangeable daylight and tungsten bulbs and power level adjustments.

Fill-in flash

On very bright days and when the subject is strongly backlit, fill-in flash is essential to avoid shadows on faces. I try not to balance the light too much otherwise it becomes a little flat and the subtleties are lost. I use the compensation buttons for increasing or decreasing the amount of flash, to fine-tune it as I want. It's tricky to get right but practising in different locations and lighting scenarios will help. You should have the fill-in flash technique mastered before you tackle a wedding.

Reflectors

As an alternative to flash, you can use a reflector to bounce sunlight on to a subject. They come in portable, pop-up form in white, gold or silver, with white being the softest and gold being very warm. All are useful and you can see the effect the reflector is having on the subject and adjust its position accordingly. I also use a diffuser to soften harsh sunlight. This is only practical when you are working on a specific shot and it is difficult without an assistant to support it. If you are working alone, ask one of the guests to help you.

Tripods

A tripod is an essential tool. Although I use mine less frequently now that you can maintain quality at a high ISO rather than using long exposures in low light, it's always in the boot of my car. There are always those occasions when you want to do a really long exposure, or to fix the frame for more measured shooting. A monopod is a handy alternative in crowded and tight situations and it can be useful for raising the camera high above a crowd for a wide shot, with the self-timer set to make the exposure.

Bags

There is no such thing as the perfect bag – you need different bags for different jobs. By the time you have taken your camera, flash and main lens out and hung it around your neck, you may find yourself lugging around a big empty bag.

I like to have the main gear I need on me and a smaller bag, carrying additional lenses, close to hand. Other spare gear is either in the car or out of the way at the venue.

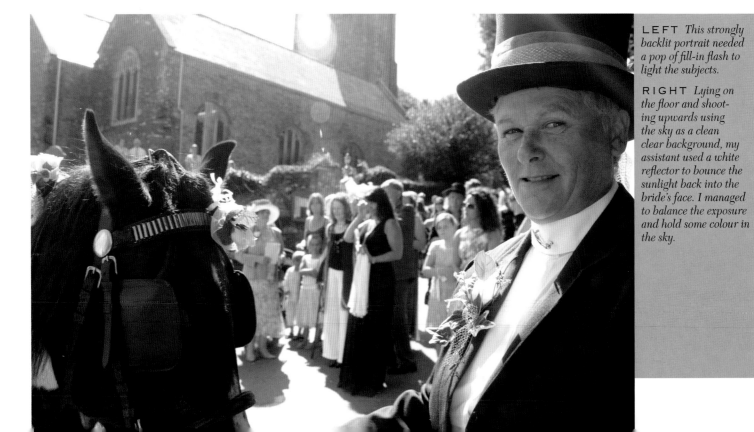

LEFT *This strongly backlit portrait needed a pop of fill-in flash to light the subjects.*

RIGHT *Lying on the floor and shooting upwards using the sky as a clean clear background, my assistant used a white reflector to bounce the sunlight back into the bride's face. I managed to balance the exposure and hold some colour in the sky.*

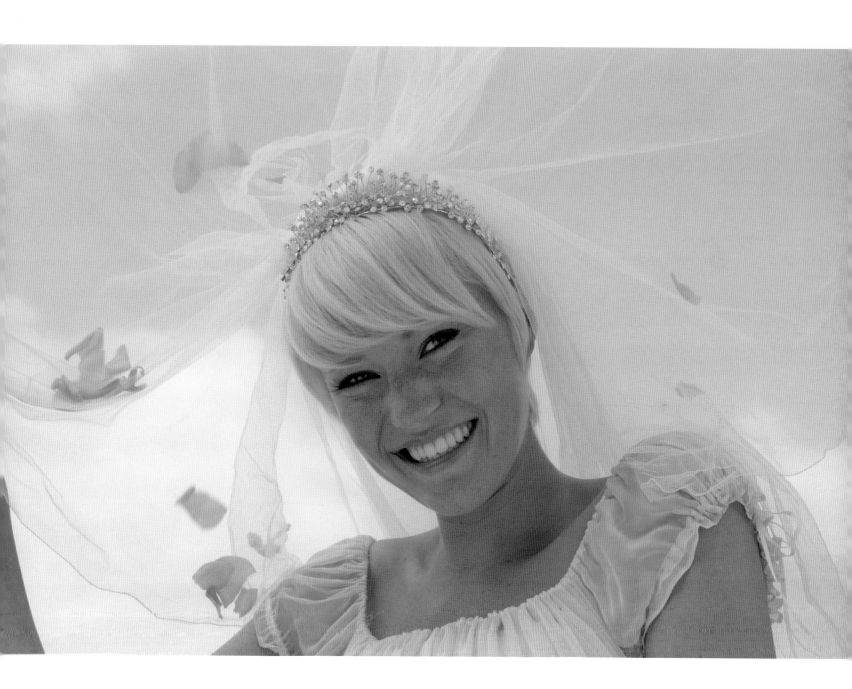

Computers and printers

The main consideration here is that images (particularly RAW) and image applications are hungry for memory and processing power. Don't expect to be able to work efficiently or effectively if your machine hasn't got a relatively high specification.

For an ideal set-up, you will need your hard drive to be fairly large, as applications can take up a lot of space. A 'start-up' or main hard drive will run your operating system and applications, so don't foul this up by using up all the space for storing your images. Use a separate hard drive, internal or external, for storage (internal or networked is preferable as it's not limited by USB/FireWire transfer speeds). A RAID system is the safest and most secure as it duplicates and is constantly backed up if one hard drive fails.

Get as RAM much as you can afford. This will increase the speed of the computer and the applications will open and run more effectively, which is so important in aiding your workflow as it should mean you are never slowed down waiting for your computer to catch up. Avoid downloads as they can interfere and undermine your system. Keep it squeaky clean and well managed for efficiency.

You will need a high-resolution monitor. Look for one with a good contrast ratio – cheap flatscreen monitors are simply not capable of displaying a good range of tones. Your monitor should also be capable of basic calibration.

I have said it once and I will say it again: always back up your digital files, preferably twice, and keep one copy off site. External hard drives are the cheapest and most convenient way to do this.

Software

Photoshop is an indispensable tool for most photographers and you will want to run this alongside software for processing RAW files, such as Adobe's Lightroom, Apple's Aperture or Nikon's Capture (see Software, page 128).

Printers

When it comes to printing your images, whether just for proofing or final prints, remember that the margin for error is huge. There are many things that will affect it overall and these will need to be considered.

Over the years I have struggled to achieve prints looking the way I want them and to perfect the printing process is a skill all of its own. My advice is to keep it simple when starting out and eliminate as many 'what if' scenarios as possible. For example, use a good quality photo printer with the inks and paper that were designed for it. Yes, you can get cheaper inks and cheaper papers, but are the colour profiles going to match? It's one less thing to worry about if you can rule out that particular problem.

Let the application you are printing from handle the colour management, at least that way you have a starting point. It's trial and error and can be incredibly frustrating.

Bear in mind that lots of little things can affect print. My previous studio was very cold and this could affect the ink flow. Eventually we found that we got better results when we printed after the heating had been on and it had warmed up a little bit. However, this was only ascertained after a lot of calibration specialists had been to look at my system.

You will find in this business, one person will tell you one thing and someone else another. There are many different ways to crack a nut so find one that works for you and stick with it. Persevere, as ultimately it's very satisfying to take your image through to the final stage as you envisaged it.

Make sure you find a system of hardware and software that will 'talk' comfortably with one another. It also needs to be powerful enough to handle all your requirements and have sufficient memory for the job.

Understanding exposure

The vast majority of people resort to using the auto mode on their cameras. Digital SLRs are now are so sophisticated and 'intelligent' that the accuracy they can achieve is incredible, however, there will still be many occasions when your camera won't be able to read the scene, or will read it and interpret it in a way that you don't want. If you want creative control in your work then you need to fully understand the basics of making an exposure.

Aperture

Exposure is controlled by three settings on the camera: aperture, shutter speed and ISO. The aperture is measured in f-stops, and refers to how much light can pass through the lens to the sensor or film.

Just as the iris of your eye responds to light and dark by increasing and decreasing in size, the leaves inside your lens adjust the size of the aperture. The larger the diameter of the aperture, the more light can pass through the lens and the smaller the f-stop number. The smaller the diameter of the aperture, the less light can pass through the lens and the higher the f-stop number. The aperture also controls how much is in focus. This is called 'depth of field' (see opposite).

Shutter speed

The shutter speed controls how long the shutter is open for, allowing more or less light to pass through the lens. Fast shutter speeds allow less light to pass through the lens and are useful for 'freezing' fast movements. Slow shutter speeds allow more light to pass through the lens and can be used in dark conditions or to produce motion blur effects. If you go below 1/60th of a second you will generally need a tripod to avoid camera shake.

The ISO

Strictly speaking, ISO refers to the light sensitivity of film. In layman's terms, ISO 50 is 'slow', making it useful for bright environments because it produces no 'grain', whereas ISO 1200 is 'fast' – useful for low-light situations, and grainy.

The ISO setting on a digital camera works in much the same way and controls how sensitive the image sensor is to light. The lower the ISO, the lower the sensitivity, which means that more light is required to produce a correct exposure but images have very little 'noise' (the digital equivalent of grain). The higher the ISO, the higher the sensitivity, so less light is needed to produce a normal exposure. This also results in more noisy images with less recorded detail.

Camera settings

A correct exposure is achieved when all three settings (aperture, shutter speed and ISO) are balanced and trimmed allowing the right measure of light to reach the sensor or film. Understanding how each one of these settings can be used to manipulate an image is the trick to becoming a more accomplished and creative photographer.

When your camera is set on manual you will decide on all three settings. I find this is the mode I naturally default to as, unless you have a very even light source and are shooting similar scenarios, settings need to be changed regularly and I like to have control. It does require your brain to work hard having to constantly check your meter and change and adapt your exposures, not easy for a novice under pressure, but you should try to work this way at least some of the time. I appreciate that I have become very quick at this over the years, but in certain situations there is no substitute for working the 'old-school' methods.

Set on aperture priority, the aperture will remain fixed on an f-stop of your choice and the camera will automatically adjust the shutter speed; the ISO setting will not be affected. Set on shutter priority, it's the other way round, so you choose the shutter speed and the camera adjusts the aperture. I like to use these settings when events move too quickly for me to expose manually or if I am outside, shooting candidly, the light levels are fluctuating rapidly and I don't want to have to worry about constantly changing exposure. I will set the camera on aperture priority at f/5.6 or, if I am using a longer lens and camera shake is a risk, I'll choose shutter priority at 1/250sec and may increase

the ISO if the light levels are low, to avoid the camera selecting an aperture that is too wide to give me enough depth of field.

It's a case of horses for courses. There are no definitive rules but your repertoire of knowledge will grow and you'll become faster as you gain experience. If you always rely on the camera to work out the exposure, I doubt you are going to get consistent results or learn how to improve.

Depth of field

The term 'depth of field' describes the distance in front of and behind your subject that is sharp and in focus. Three things control it: the aperture, the focal length of your lens and the distance you are to your subject.

A large aperture produces a shallow depth of field with only a narrow plane of focus. This can be used to good effect if you want to soften the background and keep only your main subject the point of focus. In contrast, the smaller the aperture, the greater the plane of focus, which is important if you want to show more, or all, of the detail in the foreground and distance. Typically, this would be for landscapes or bigger groups, where you want everyone, including perhaps the venue behind, to all be in focus.

A long lens focused close to your subject with a wide aperture will maximize the effect of a shallow depth of field, whereas a wide lens with the smallest aperture, well back from your subject, will offer the greatest depth of field.

There is a complex science involved in all this and you will find that some of the explanations of depth of field in text books can be really confusing. Experiment with the different apertures on each of your lenses and you will see for yourself the effects that can be achieved.

8. Before and After the Wedding Day Shots

The couple sometimes request, or could be interested in, another shoot before or after the wedding day and you should consider offering this as an option to clients. As mentioned before, it's a great marketing tool to bolt on to your existing wedding package – you can offer these shots as an incentive to secure bookings as well as making extra sales. Lots of couples like to include these images in their finished collection, use them in the design of their invitations or thank-you cards, or give as gifts to parents or each other.

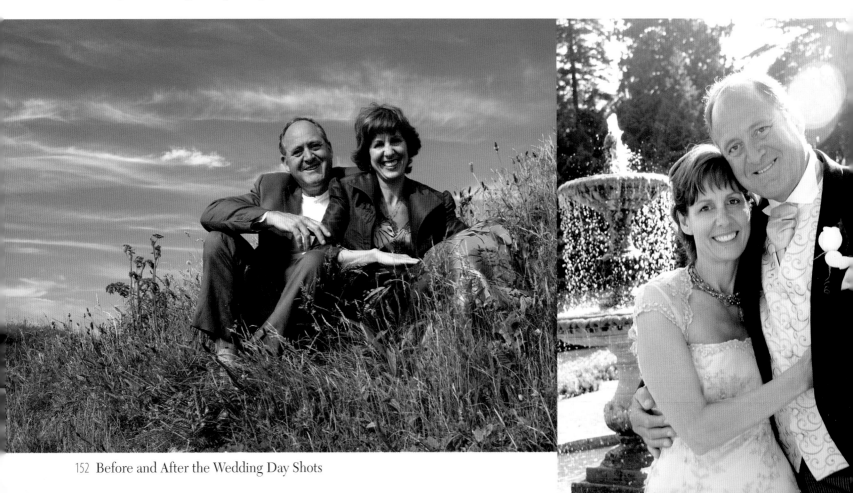

I offer a range of pre- and post-wedding packages, from simple portrait sessions either in the studio or on location including a 'nude you' shoot for couples looking for a very personal gift for one another, and a post-wedding 'trash your dress' shoot. This is not to be taken literally but is simply an opportunity for the bride to wear her dress again and have a bit of fun with it.

One of the most rewarding aspects of my work, in addition to the pleasure of creating images, is building an ongoing and happy working relationship with my clients. I have met so many great people over the years and, although it is a business and I always keep my relationship on a business footing, it's very heart-warming when customers return with their

bumps and babies and extended families or require a commercial shoot for their business needs. If you do your job properly (and with weddings there is no second chance) then you secure, at the very least, the satisfaction of a job well done and perhaps an opportunity to work with your couple again.

As well as shooting weddings, I also run a portrait and commercial studio so I am well placed to offer these additional services to my wedding clients. There is no reason, however, why you shouldn't be able to offer something similar. You may already have a studio set-up but if not you can offer location shoots. A lot of professional photographers choose not to have the overheads of running a studio and market the 'location' as a selling point.

Engagement portraits

I often arrange an engagement shoot with the couple. This can be really useful if they are nervous or unsure about being photographed as it will help them understand the process of being directed and they will feel much more confident with you on the actual wedding day.

I strongly recommend that you scout some good locations for this shoot, taking into consideration the possibility of wet weather. Don't just pitch up at your local park; it may be green and open but that isn't always going to offer the most interesting setting. Grungy urban spaces may have as much potential as a beautiful natural landscape. The couple may also have a specific location in mind. Once you have established a reliable setting and have clearance to shoot there, make sure that you do a few test shots to see how it looks through the camera.

For a straightforward portrait session with the couple you should probably allocate an hour for shooting with a little extra time to meet up and get to the location. When taking the pictures, the same rules apply as on the wedding day: communicate well with the couple, have a firm idea in your mind of what you are hoping to achieve and give them clear direction. Don't ask them to do anything they are not going to feel comfortable with; remember some couples are better at this than others. These sessions should be really enjoyable, freed from the time pressures of the wedding day.

Boudoir shots

For the 'nude you' or boudoir shoots, you will obviously need a private location where your client can feel comfortable and safe. Photographers will sometimes book or make an arrangement with a hotel. I also offer a 'nude in the landscape' shoot as I am lucky enough to work in an area of outstanding natural beauty, but privacy and the weather can be an issue.

This type of shoot will require an entirely different approach from the conventional engagement portraits and needs careful management. Don't offer it unless you are really confident at handling and directing a very personal and private session. If you are a male photographer, it may be wise to have a female associate working with you to reassure your client.

Not all clients will want total nudity; some will want to be photographed in their lingerie. I also use a selection of

soft fabrics and gauze to conceal and reveal, as well as a dressing gown for the client to wear while setting up the shots.

No matter how comfortable he or she is about stripping off, your client will no doubt feel apprehensive, so lots of confident reassurance from you will be needed. Most of us have been on a beach in very little clothing, but it is a very different experience in the confines of a studio or room with a relative stranger. Looking good naked and feeling good naked are also two very different things. I find that once the robe is off, any awkwardness disappears after about five minutes.

I always make sure I know exactly what 'look' my client is hoping to achieve before I start to shoot, and that I understand how they feel about themselves. Initially, I suggest you perfect a few safe, classic poses and develop your style and repertoire with each further shoot you do.

Trash the dress shots
On the wedding day itself there is often precious little time to work with the couple, so to arrange a full, dedicated shoot after the wedding is a great opportunity for some creative images. When you consider the expense and effort that goes into the purchase of the dress, it seems such a shame that it only gets worn once, and generally brides love the opportunity to wear it again.

Also, it can be a bit of an anti-climax after the wedding and honeymoon is over, especially after so much build-up beforehand. Sometimes doing a shoot like this can help to tie it all up for the couple and bring the occasion to a satisfying close.

Trash the dress, as I have said, doesn't actually mean ruining it. It's about the bride having more freedom while wearing it than she did on the day. If the idea doesn't appeal to her, you can offer a more formal shoot but with an unusual or quirky twist – perhaps styling the dress differently with added props.

Other opportunities

It is unlikely that every one of your clients will opt for all these additional shoots. A wedding and honeymoon can cost a small fortune and most couples will have to prioritize their spending. However, it is definitely worthwhile marketing the shoots around your core services as this will show your clients how diverse your business is. In order to survive in today's competitive market, this is an absolute must. It's very easy to become pigeonholed or typecast and if you want other work in addition to weddings, establishing this at the outset with your existing clients is a really good idea.

Make sure your records are kept up to date and spend time nurturing your mailing list. Make a point to make a note in the diary of previous clients' forthcoming wedding anniversaries and Valentine's Day. These are good opportunities to contact your couples with a special offer on prints and products. Often there will be something that they particularly wanted when they placed their first order but perhaps couldn't afford at the time.

Bumps and babies

Bride and groom usually become mum and dad within three to five years, and if you have done your job well and can forge an ongoing relationship, then the family shoot can be a very good source of regular income.

Build a programme of shoots that gives the customer an incentive and a clear idea of what they are buying into. My programme starts before the baby is even born – 'bump to baby'. This involves a six-month bump shoot, when the bump is neither too big or too small, a newborn baby shoot (up to ten weeks),

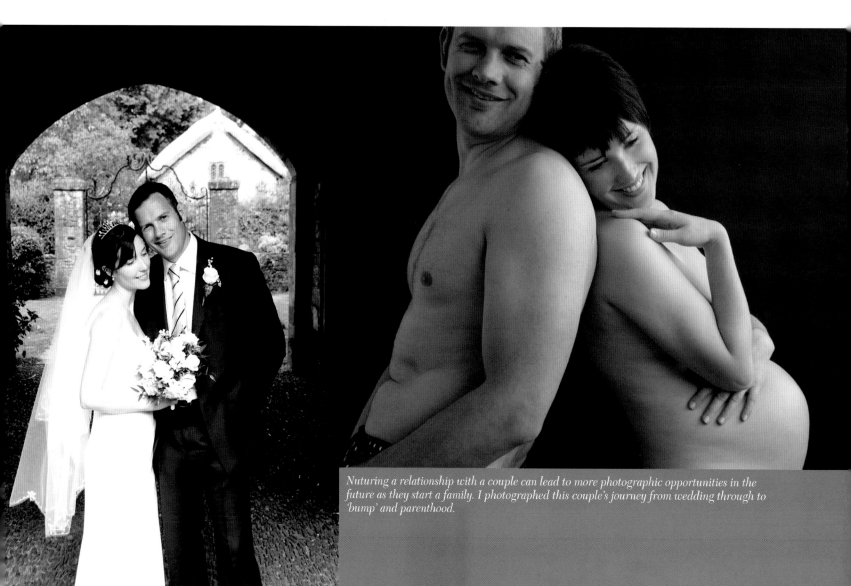

Nurturing a relationship with a couple can lead to more photographic opportunities in the future as they start a family. I photographed this couple's journey from wedding through to 'bump' and parenthood.

another at six months when the baby can usually sit up confidently but is not yet crawling, and lastly, a shoot when they are toddling.

Package this in stage payments so the couple see it as a long-term investment. You will need to set this out as clearly as possible as new parents have plenty to deal with and won't want to bother with anything that seems too complicated. You may not be asked to do every shoot but having a structure in place will increase your chances for more business.

This may sound like this is putting too much pressure on your client to buy and so I would beware of the hard sell. Set out your wares, encourage, but don't browbeat.

Through this book I hope that you have gained a greater insight into the discipline of wedding photography.

It's been a long journey from shooting my very first wedding all those years ago, to the standard and level of service I am now able to offer. I am, however, still filled with nerves before I set off to cover a wedding. The responsibility carries huge pressure but the day I stop worrying about it, will be the day I retire – it's a serious undertaking not to be entered into casually. The Dream Wedding is for the couple. That is exactly how it should be and your role as their photographer on the most important of all days is critical. They will have so many happy memories and it is your job to capture it all: to provide an evocative representation of the day from its best side. If you have done your job properly they will cherish the photography forever.

Dream Wedding…Dream Job…

Index

About the Author

Lorna has worked at the high end of the photographic industry for over twenty-five years. She came into the business at an early age from a professional arts background and learnt her craft working alongside some of Britain's leading photographers.

Lorna left London to relocate to her native Devon where she established her studio, and set about dispelling the tired and staid image of social photography. Lorna pioneered the reportage approach in her bridal work which has been widely emulated.

Recently expanding her position in the photographic industry she established bangwallop, a fun and innovative photographic venue in the beautiful cosmopolitan resort of Salcombe. Lorna and her highly-skilled team, have created an extraordinary and exciting photographic company, with contemporary wedding photography and training at the heart of its business.

Acknowledgments

I would like to acknowledge and thank my team past and present, who over the years have worked closely alongside me in my business, processing and perfecting the images that I make – it really is very much a joint effort.

Thanks also to the lovely people at David & Charles for the fantastic opportunity to produce my own book.

To Steve my business and life partner, thank you for putting up with me. And to my lovely mum who encouraged me and gave me the opportunity of a first class arts education.